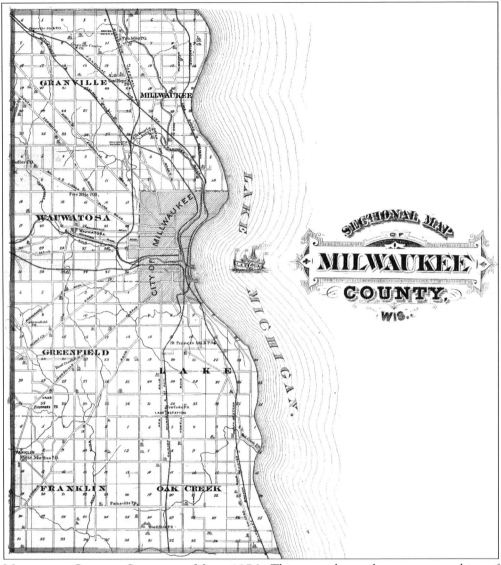

MILWAUKEE COUNTY SECTIONAL MAP, 1876. This map shows the seven townships of Milwaukee County in relation to the City of Milwaukee. The future City of West Allis would occupy the southern part of Wauwatosa Township and the north and west-central portions of Greenfield Township. (Photo courtesy of the Milwaukee Public Museum.)

IMAGES of America
WEST ALLIS

Albert Muchka

Copyright © 2003 by Albert Muchka
ISBN 978-0-7385-3183-0

Published by Arcadia Publishing
Charleston, South Carolina

Printed in the United States of America

Library of Congress Catalog Card Number: 2003111928

For all general information contact Arcadia Publishing at:
Telephone 843-853-2070
Fax 843-853-0044
E-mail sales@arcadiapublishing.com
For customer service and orders:
Toll-Free 1-888-313-2665

Visit us on the Internet at www.arcadiapublishing.com

For my mentor and friend in local history,
a true resource and treasure,
John Clow

Contents

Acknowledgments		6
Introduction		7
1.	Pioneers, Promoters, and Industrialists	11
2.	Industrial Capital of Wisconsin	29
3.	Making a New City	41
4.	Back on the Block: Homes and Businesses	61
5.	Schools, Parks, and Churches	83
6.	Meet Me at the Fairground	99
7.	Remembrance and Celebration	113

Acknowledgments

I would like to thank the following individuals and organizations for their assistance in the creation of this work. Their generous help and advice made this book possible. Primary assistance and unprecedented access to photographic and archival collections was granted by the board and members of the West Allis Historical Society, Devan Gracyalny, president, and John Clow, library chairperson. A great debt is owed the late Margaret Jane "Peg" Park, curator of the West Allis Historical Society's collections, for her devotion to compiling and interpreting West Allis' rich history.

Great assistance, support, and encouragement was given to me by the City of West Allis Historical Commission, Mayor Jeanette Bell, Chairperson, and Patrick Schloss, Department of City Development Staff Liaison. Additional thanks to the staff of the West Allis Public Library, Anne Shepherd, director, and the incredibly able and tolerant reference section librarians without whose help every researcher would be lost. Additional support, information, and photographs were provided by Sharon Clow, Barbara Hart, Pat Morris, and other citizens of West Allis too numerous to mention individually.

Special thanks are due to Jerry Zimmerman, historian, Wisconsin State Fair Park, for his advice, stories, and access to photographic collections. Generous assistance and photographs were provided by the Milwaukee County Historical Society, Dr. Robert Teske, director, and Steven Daily, archives curator. Additional photographs were generously provided by the University of Wisconsin-Milwaukee, Golda Meir Library, Urban Archives, Mary Huelsbeck, archivist. Also, a special thank you is due to Sarah Johnson of the Journal Sentinel Inc., for her tolerant assistance in searching out photos for this work.

Very special thanks to my colleagues at the Milwaukee Public Museum History Section for access to local history materials and collections, professional encouragement, and the time to work on this project. I am greatly indebted to Joanne Peterson and Susan Otto of the Milwaukee Public Museum Photographic Section for access to museum photographic collections, photographic and computer equipment, and services.

Lastly, but never least, I thank my wife Sandy who has tolerated my foibles for 25 years. Without her loving encouragement, help, and compassionate ear, I would never have come this far in life and career.

As with any finite work it is impossible to address every nuance of a community's history. Dates and interpretations of events vary and often compete against themselves. A best effort was made to provide the basics of West Allis history. The author accepts responsibility for any and all errors and omissions.

All photos are from the West Allis Historical Society unless otherwise noted.

INTRODUCTION

West Allis is nestled in the heart of Milwaukee County, Wisconsin. The Milwaukee and Menominee Rivers dominate the county, but it was along the smaller rivers of western Milwaukee County that some of the earliest inhabitants made their homes. In the 1850s, Increase Lapham (1811-1875), an engineer, scientist, and father of the National Weather Service, mapped Milwaukee County and took note of the habitations of the current Native American groups. More interestingly, he noted the positions of ancient earthworks built by Woodlands people (A.D. 100-1000) simply know as the "Mound Builders." Hundreds of mounds were identified across the county. Conical burial and effigy mounds were identified and mapped in Greenfield Township, not far from the site of the Honey Creek Settlement, in what is today Wisconsin State Fair Park. Many other mounds were identified where the southeast corner of the future city of West Allis touched upon the ancient "Indian Fields" of Section 11, Greenfield Township, southeastward from South Fifty-second Street at Kinnikinnic River Parkway. Indeed, that simple evidence shows that the area was well-settled by ancient peoples nearly a millennia before the coming of the first Euro-American settlers.

The basins of Honey Creek, Root River, and the Kinnikinnic River meander through large wetlands with low, rolling hills thick with wooded lands and dotted with small ponds. It was extremely fertile ground dominated by deciduous forests and, toward the southwest, oak prairie. In the last 300 years the Pottawatomie and Menominee were the predominant native people. Rich animal resources were hunted and traded by Native Americans during that time to itinerant French, English, and, later, permanent American traders and merchants. Some of these men were well aware of the agricultural and monetary potential of the land and set their minds to buying some of it for themselves. Land became a commodity with new residents buying up as much as 160 acres and as little as 40 acres.

From 1805 to 1836 Wisconsin was successively part of Indiana, Illinois, and Michigan Territories. Throughout this time the United States government worked to obtain rights to the land in territories from the Indians. Between 1827 and 1833 most of the land of southern Wisconsin was ceded to the government and the job of clearing out the Native Americans began. Most native people were removed to lands west of the Mississippi River by the end of the 1840s.

Milwaukee County was formed by the Michigan Territorial Legislature in 1834. Land sales in the newly formed Wisconsin Territory opened at Green Bay in 1836, and many fine parcels of land were sold for farms, with some land falling into the hands of men who resold the land for quick profit. As land sales progressed, the county was divided in to seven townships between 1838 and 1841. Greenfield Township was formed in 1839 from the expansive Kinnikinnic Township, which originally encompassed the bulk of the western and southwestern part of Milwaukee County.

Between 1835 and 1845 many of the first families of Honey Creek Settlement arrived from New York and New England, settling on rich farms and woodlots. Among the many pioneers were the families of Rueben Strong, Eber Cornwall, William Johnson, John Cooper, and Bigelow Case. They were greeted by Antoine Douville, a French Canadian, who settled on lands along the banks of Honey Creek a number of years earlier. Their livelihoods revolved around farming, lumbering, and shop keeping. Many of the settlers hunted wild fowl, small game, and deer. Self-sufficiency and neighborly cooperation were hallmarks of their tenure on the land. Many

settlers and pioneers began their lives in Greenfield Township living in hand-hewed log cabins. Slowly they replaced the cabins with neo-classically inspired frame farm houses, mid-Victorian, and fine Queen Anne style homes. Some pioneers were involved in the establishment of township and county government, taking very serious care in the exercise of the responsibilities and limits of administration. Some built schools and became teachers, promoting the ideals of common school education in the vein of pioneer educator Horace Mann (1796–1859).

Initially agricultural pursuits were at subsistence level, supporting those living on the farm itself. After 1860, many farmers were planting wheat and other commercial crops to trans-ship through Milwaukee to hungry, growing eastern cities. But the transportation pattern changed with the coming of the railroads and their reach across the Mississippi River from Chicago into the grain producing regions of Iowa and Minnesota. Chicago became the chief grain shipment port on Lake Michigan by 1880, and the second generation farmers of western Milwaukee County shifted their attention to local markets with crops of fruits and vegetables, dairy goods, and locally produced meats. It was a healthy market, and the farmers prospered.

Part of the growth of Honey Creek depended on the system of plank roads built by local entrepreneurs. Greenfield Township was crossed by four major roads running southwest from the City of Milwaukee. They were the Mukwanago Plank Road (National Avenue), Beloit Road, Janesville Plank Road (Forest Home Avenue), and Loomis Road. Honey Creek was serviced by the Mukwanago Road with the Beloit Road scarcely a mile to the south of the village. Along the Mukwanago Road sprang a number of hotels and saloons, blacksmith shops, and grain and feed merchants. The mail was brought by stage coach twice weekly. Farmers and lumbermen plied the road, suffering the costs of the toll, which was 2¢ per draft animal per mile traveled. But the toll roads were a nuisance and in ill repair, and by the end of the 19th century they were removed as an impediment to the progress of the area.

Progress crept into Honey Creek in 1880 with the building of the Madison branch of the Chicago and Northwestern Railroad. The railroad established a station, calling it North Greenfield, and that name was taken to represent the settlement. With the railroad came more people, and land became a commodity once again. Individual land sales were for much smaller parcels than 45 years earlier, with 10-, 20-, and 40-acre plots and even smaller house lots as the norm. Also, many of the founding families had grown and divided their large farms among their children, creating even more small parcels. Agriculture and small businesses remained the life-blood of the community. But the railroad became a fundamental consideration in the growth of new industry and the creation of a new city.

By the 1890s some sections of land around North Greenfield were in the hands of local real estate developers. Lots and small parcels were sold along National Avenue slightly east and west of Wauwatosa Road (South Eighty-fourth Street). Henderson's Subdivision, promoted by brothers Fred and Stutley Henderson, was one of the earliest developments in North Greenfield and was a harbinger of future events. A most important land sale came about in 1891, when the Wisconsin Agricultural Society purchased nearly 100 acres in North Greenfield for the permanent site of the Wisconsin State Fair. With a venue located so close to Milwaukee, it became very important to extend the city street car lines to the new park. The early trolley lines were extended from the National Soldiers' Home westward up Greenfield Avenue to the fairgrounds and later up National Avenue into the heart of North Greenfield itself. This gentle growth would not have been possible without transportation infrastructure. The railroad depot put North Greenfield on the map and opened it to distant markets, but it was the extension of public transportation in the form of the street car that prepared the way for expansion of business and housing.

Industrial growth was slow in North Greenfield. Even though it was a mere six miles from downtown Milwaukee, it was initially considered too distant for workers to travel and too isolated from railheads and port facilities. Even so, one company, Rosenthal Cornhusker Company (1898–1954), a manufacturer of farm implements, successfully took a chance on doing business from North Greenfield. About that same time some large industries in the

City of Milwaukee found themselves land-locked and unable to expand. They also found that adequate housing for their workers was getting more difficult to obtain. The first to consider this problem was the management of the Edward P. Allis Company's Reliance Iron Works. Edwin Reynolds (1831-1909), a brilliant engineer and company superintendent, led the search for lands upon which the E.P. Allis Company could expand. He cast an eye toward the open lands of Greenfield Township, specifically the area east of the hamlet of North Greenfield. Of course, his gaze was assisted by the Henderson Brothers and Charles Cupple, all of whom were partners in a land business called the Central Improvement Company. They offered 110 acres of land, known as the Whittemore Farm, to the E.P. Allis Company. During the negotiations the Allis Company merged with three other manufacturing concerns to form the Allis Chalmers Company. Construction of the giant manufacturing facility began in 1901, with the first shops and offices occupied and working by the end of 1902. This bold venture enticed more industries to follow suit. Allis Chalmers was quickly followed by Kearny and Trecker Company, Pressed Steel Tank Company, and others. The railroads extended beltline service to the new industries, and the demand for worker housing rose dramatically. New subdivisions were platted by anxious real estate developers, and street car service was extended to trunk lines near the new neighborhoods. New industrial and residential growth demanded greater civic organization to meet the needs of corporate and individual citizens. It was decided to vote to incorporate a new village in 1902 and put it on the map. That village became West Allis.

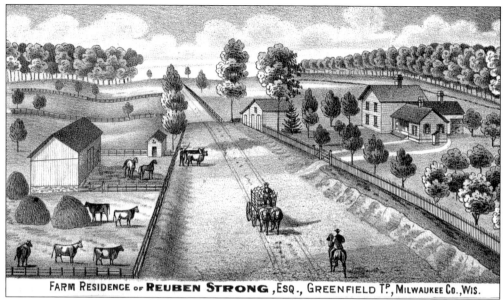

RUEBEN STRONG FARM, C. 1876. (Photo courtesy of the Milwaukee Public Museum.)

RUEBEN STRONG (1814–1889). Rueben Strong came to Wisconsin from New York in 1836, first settling on an 80-acre claim on the Janesville Plank Road. Strong was elected a judge in Greenfield Township in 1839. He later bought acreage near Honey Creek where he built the farm shown above. A small part of that land was donated for the Honey Creek Cemetery and the Honey Creek School. Strong was also a school commissioner.

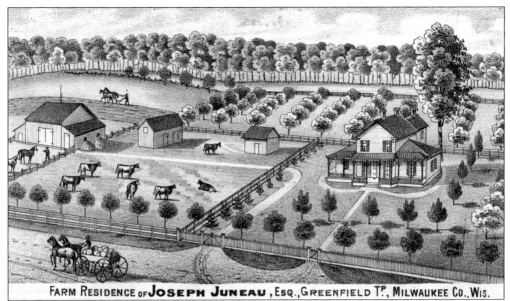

JOSEPH JUNEAU'S FARM, C. 1876. Joseph Juneau (1837-1919) was the son of Pierre (Peter) Juneau who, along with his brother, Solomon Juneau, were the acknowledged founders of the City of Milwaukee. Joseph inherited 80 acres of land in Greenfield Township and slowly built his farm into a 200-acre business. The farm was located on Beloit Road near Hawley Road (South Sixtieth Street). (Photo courtesy of the Milwaukee Public Museum.)

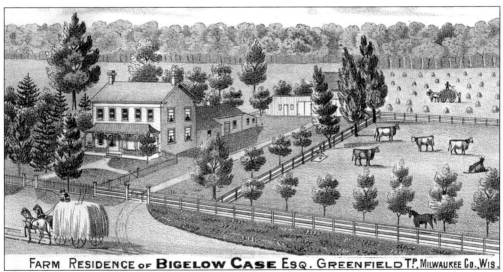

BIGELOW CASE FARM, C. 1876. Bigelow Case (b. 1811) came to Milwaukee County in 1836. He purchased 160 acres and established a farm in 1848 near Seventieth and West National Avenue. He was elected president of the Mukwanago Plank Road Company, establishing a sawmill at Honey Creek to provide lumber for the road and local buildings. Sawmill operations ceased in 1885 when the timber was exhausted. The toll road operated until 1902. (Photo courtesy of the Milwaukee Public Museum.)

JOHN BELL FARM. Captain John Bell was a native of New York State. He served in the New York Militia during the Civil War. Afterward he came to Milwaukee County, taking residence on a farm near the junction of Mukwanago Road near Root River. In addition to operating the farm, he ran one of two early roadhouses on the plank road. The other roadhouse, operated by John LeFeber, was located near present day South Seventy-first Street at National.

THE DOUVILLE HOUSE. Antoine Douville came to Honey Creek in 1837. He farmed 160 acres along the Wauwatosa Road (South Eighty-fourth Street). He occasionally lent his barn to both Methodist and Baptist congregations for services, and he was instrumental in planning the Honey Creek Cemetery. His son, Frank, built the grand Victorian house shown above. Members of Douville's family were actively involved in the growth and administration of North Greenfield and the City of West Allis.

WILLIAM WALLACE JOHNSON (1813–1900).

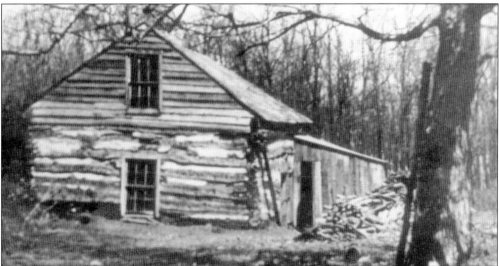

JOHNSON'S LOG CABIN. William Wallace Johnson can be considered a seminal personality in the development of Greenfield Township. Johnson was a man of letters and great religious conviction, having proven himself devoted to issues of education in his native Massachusetts. He migrated to Milwaukee County with his wife, Abigail Clark Johnson, in 1842, following the urging of his brother Edwin who arrived in Greenfield Township a year earlier. The log house shown below was built on land William bought near Edwin (South Eighty-fourth at Beloit Road). The Johnsons worked for the community good; Edwin donated land for a school, while William was a school commissioner, town treasurer, town clerk, trustee of the Honey Creek Cemetery Association, and a Methodist minister. A lasting legacy of William Johnson is his diary that outlined many details of early life in the township.

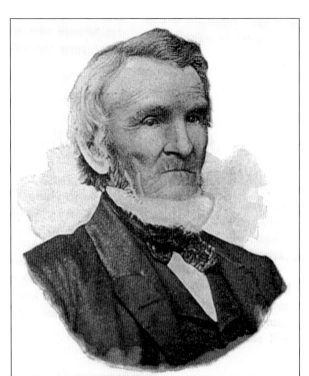

EBER CORNWALL (1792–1880).

THE CORNWALL HOME. Eber Cornwall came to Milwaukee County with his nephew, Peter Marlett, in 1835, to stake a claim on the lush lands in Kinnikinnic Township. They immediately returned east to bring their families to the new lands. Cornwall returned with his wife Cynthia and eldest son Nathaniel in 1836. They built a log cabin and began to farm. Cornwall and his family were devout Baptists and were founders of the Greenfield Baptist Church (1841). The congregation, lacking a church, met in the Cornwall cabin beginning in 1837 and later in the frame house built in 1848. The frame house still stands today near the corner of South Eighty-fourth Street at Greenfield Avenue.

JOHN COOPER (B. 1810).

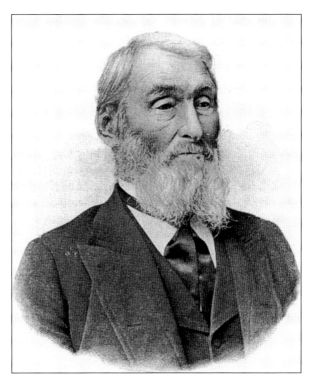

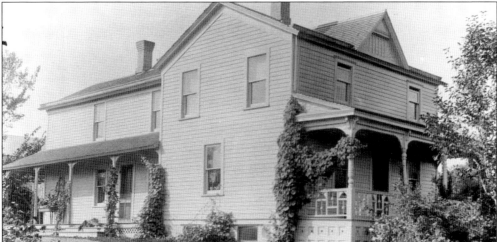

THE COOPER HOUSE. John Cooper came to Milwaukee in 1837 following the previous migration of his family in 1836. Land was bought in Section 18 of the township, and John and his brother Alexander built a fine farm and orchard. John Cooper served the pioneer community as postmaster and justice of the peace and donated an acre of land for a school at the western edge of Milwaukee County near the Root River. In 1844 he married Marion Johnson, who was a teacher in the school built near his home. She was also responsible for obtaining many of the apple varieties grown in the Cooper orchard. Cooper served as a representative to the Territorial Convention of 1846. He also served on the school board and as town chairman for many years. The frame house above was built in 1844 and served many generations of the Cooper family. The Cooper farm was well-known for its orchards, forage crops, and registered dairy cattle. In the early 1960s the farm gave way to a housing development along the Root River.

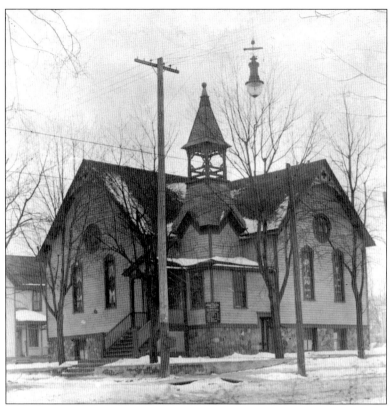

NORTH GREENFIELD METHODIST CHURCH. Methodism was practiced by many of the Greenfield pioneers. For many years the congregation met in members' homes in the North Greenfield and southern Wauwatosa area. This church was built in 1888, occupying the corner of present day South Eighty-first Street at Beecher. William Wallace Johnson was a founding member.

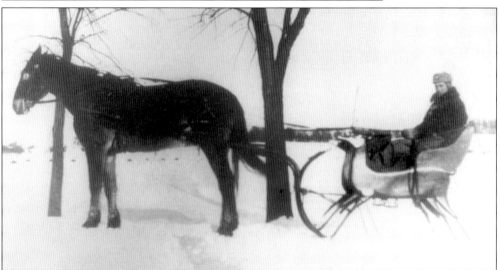

RURAL FARM DELIVERY. Mail delivery was a very important means of communication for North Greenfielders. Earliest mail delivery came by stagecoach twice weekly, traveling along the Mukwanago Road westward from Milwaukee on Tuesday and easterly from Madison on Thursday. Early postmasters collected and distributed mail from their homes and businesses, having no official post office building. This photo depicts mail delivery by sleigh c. 1900. By 1907 the West Allis post office was a substation of the Milwaukee post office, and mail delivery to homes in the new subdivisions commenced.

HERMAN RUST HOME.

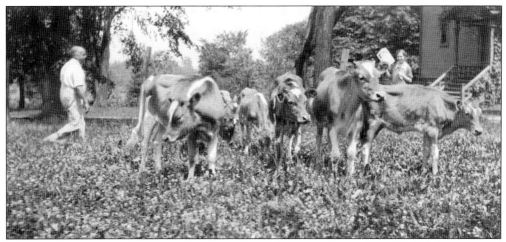

COWS IN THE FLOWERS. In about 1849, the Rust family settled in Greenfield Township. Over the ensuing years they acquired farm lands in Sections 7, 8, and 18. Brothers John, Henry, Herman, and Julius raised dairy cattle, forage, fruits, and vegetables. They all lived on separate farms but worked in concert with each farm, producing a specialty product. Julius and his son, Arthur, specialized in raising prize-winning Friesian-Holstein dairy cows, many of which were sold to dairymen in Japan to form the nucleus of Japan's dairy industry in the 1890s. It is said that cows and foreign dignitaries abounded at the Rust Farms. The last of the family to practice farming was Fred Rust, who, after the mid-1920s, turned to real estate, banking, and politics, later serving as an alderman for the City of West Allis. The Rust home, shown above, was located near 107th and West National Avenue. It was demolished in the late 1960s.

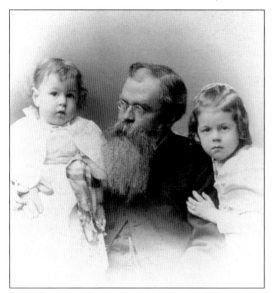

JOHN LENDRUM MITCHELL (1842–1904) AND CHILDREN. John Lendrum Mitchell was the son of Milwaukee pioneer businessman Alexander Mitchell. John served in the Civil War in the 24th Wisconsin Infantry. He studied law, spoke five languages, and served in The Wisconsin State Senate and, later, the U.S. Senate. Most of all he was a great supporter of veteran affairs, labor reform, the arts, and was deeply involved in agricultural pursuits. He was well-known as a devoted father, spending much time with his family and tending personally to the childrens' education. Like many Milwaukeeans he bought farmland in Greenfield Township as an investment and an escape from city life. (Photo courtesy of the Milwaukee County Historical Society.)

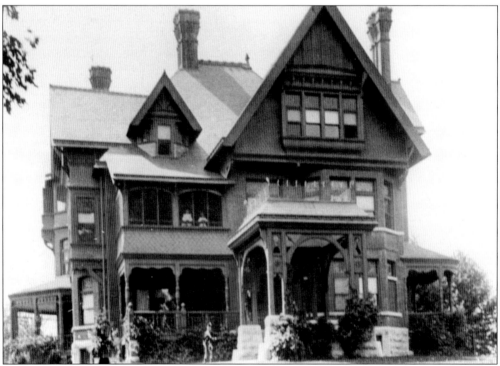

MEADOWMERE. Meadowmere was John Mitchell's stately family home and farm. It was designed by noted architect Edward Townsend Mix in 1878 and was built on 480 acres of land near the Kinnikinnic River (currently South Fifty-fourth Street at Lincoln Avenue). The house was completed in 1883. The Mitchells were well-known for their art collection, library, and constant entertaining of statesmen and artists. The Mitchell family owned the property until most of the acreage was sold in 1924 for housing development. The house was sold in 1936 to the Carmelite Sisters for use as a mother-house and nursing home. The stately mansion is today part of the Mitchell Manner care facility. (Photo courtesy of the Milwaukee County Historical Society.)

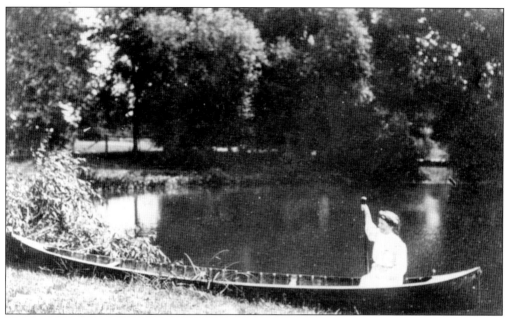

CANOEING AT MEADOWMERE.

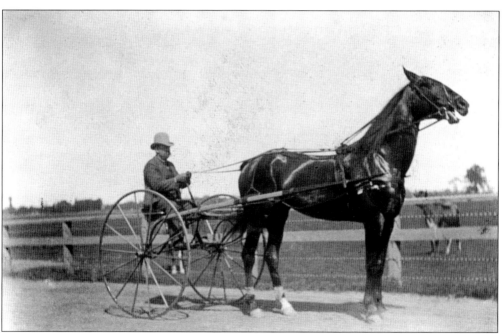

HORSE TRACK AT MEADOWMERE. Meadowmere was a model farm. John Mitchell was a breeder of prize-winning cattle and trotting horses. He also experimented with scientific farming techniques. Here John Mitchell shows off a prize winning horse at the Meadowmere track. Above, one of Mitchell's daughters takes a leisurely paddle on the pond at Meadowmere. The pond was created by a dam on the Kinnikinnic River near South Fifty-fifth Street. (Photos courtesy of the Milwaukee County Historical Society.)

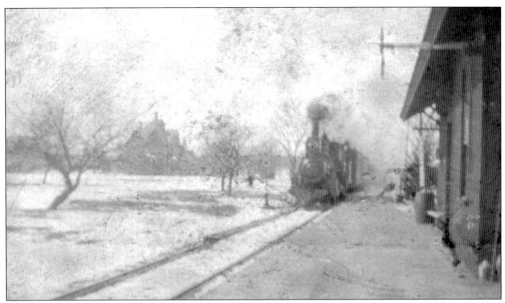

THE CHICAGO AND NORTHWESTERN STATION, C. 1890. Railroads were very important to the growth of West Allis. The Chicago and Northwestern Railroad built the "Milwaukee and Madison Line" through the heart of Honey Creek in 1880. They erected a station, calling it North Greenfield. The people of Honey Creek took the name "North Greenfield" as the name of the town in 1887. The railroad created a link to new markets for the local farmers and was a deciding factor in the building of future industry. The station was known as North Greenfield Station until the early 1920s when it was renamed West Allis Station.

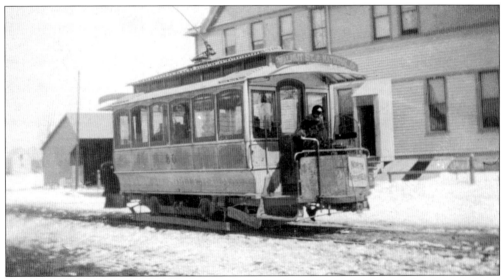

EARLY STREET CAR, C. 1900. Street cars were the only practical way for people to move about the City of Milwaukee. Service was extended as businesses and residences sprang up west of the city. In 1891, street car service extended to the National Soldiers' Home. Street car service was extended to State Fair Park via Greenfield Avenue in 1894. By 1900 service arrived in North Greenfield and its sister village, Wauwatosa. This street car was part of the National Avenue line and is seen at "Mergler's Corner" (South Eighty-first Street at National Avenue).

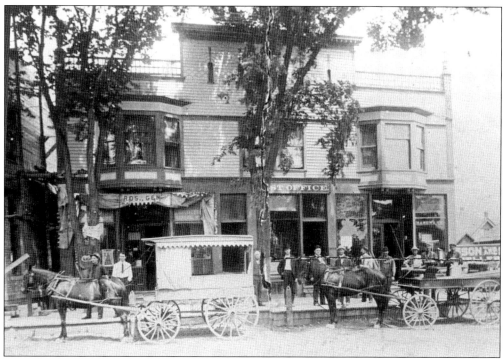

DOUVILLE BUILDING (BUILT 1882), C. 1905.

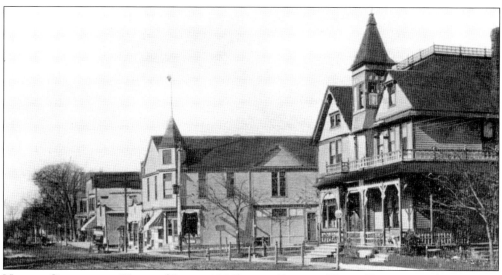

NORTH GREENFIELD HOTEL (BUILT 1889) AND POIRON HALL (BUILT 1897), C. 1900. Many of the business buildings in North Greenfield were built by the children of the pioneers and by new businessmen who came to the area in the 1880s and 1890s. During the late 19th century, businesses like these lined National Avenue from Seventy-eighth Street to Eighty-fourth Street. These buildings served not only as inns and shops, but also as the post office, local library, town hall, and entertainment center. The hotel was a popular stop for Milwaukeeans heading west to the Waukesha lakes country. Over the years the Douville Building housed a grocery store, hardware store, and a clothing store run by Max Stern.

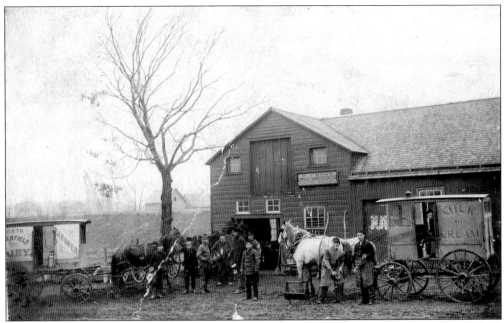

CROSS BLACKSMITH SHOP, C. 1890.

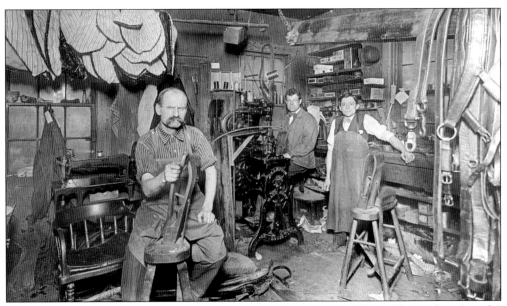

WELSAND HARNESS SHOP, C. 1910. The economy of 19th-century West Allis was based on the horse. Farms depended on their horsepower, and travelers depended on their speed and reliability. Blacksmithing and harness-making were essential crafts. The first blacksmith in the township was Alexander Cooper in 1837. Wallace Cross's shop also served as a mail drop for the incoming mail. Cross died in 1897. The shop was run by Lawrence Blenker until 1918. Another well-known blacksmith was Charles Liebenthal, who operated his shop next to the Douville Building until 1924. By the time these photographs were taken, Liebenthal and Welsand's days were numbered as the automobile and street car began to replace the horse, and the farms of North Greenfield gave way to workman's homes. By 1937 the blacksmiths of West Allis were gone.

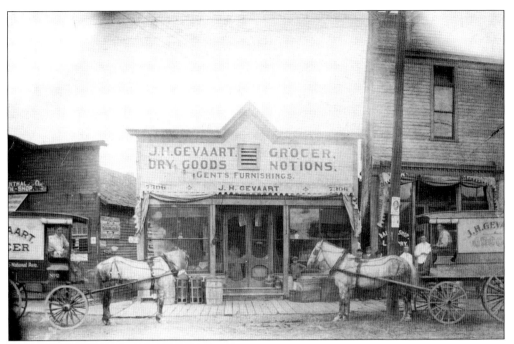

GEVAART GROCERY, 1893–1933.

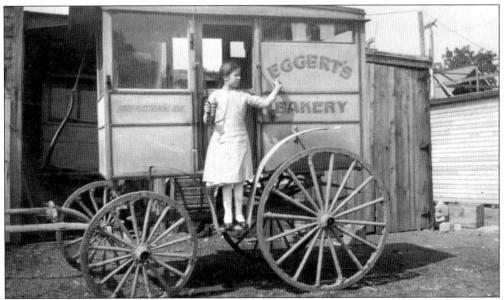

EGGERT BAKERY WAGON, C. 1910. Small business was the heart and soul of the area. Many were aimed at providing the goods and services that could not be raised on the farm. Some catered to the new residents who came to the recently established subdivisions, worked in the city, and had no time to grow or make their own food. Shopkeepers like Gevaart and Eggert used wagons to bring raw materials to their stores and deliver goods to outlying farms and city customers. Gevaart also was a major supplier to the dining halls and food stands of the Wisconsin State Fair. Both shops were in the vicinity of South Eighty-first Street at National Avenue.

FREDERICK HENDERSON.

HENDERSON'S SUBDIVISION ADVERTISEMENT, C. 1887.
Frederick Henderson and his brother, Stutley I. Henderson, were responsible for the initial growth of the village of North Greenfield in the post pioneer period. They platted the first subdivision in the area called Henderson's Subdivision Number One. It contained 400 home-sites on the northeast side of the village. Fred was a lawyer and was elected the first president of the Village of West Allis in 1902. He also served as village attorney, retiring after two years of service. He withdrew from public life in 1905 due to ill health.

CHARLES CUPPEL (1838–1911). Charles Cuppel was a native of Milwaukee who was a great believer in the potential of the area. He owned many acres in the Five Points district (the juncture of Greenfield and National Avenues). In 1901 he was instrumental in drawing Charles Allis and Edwin Reynolds to Greenfield Township to establish the great Allis Chalmers Works. In 1902, during construction of the factory, a public meeting was held at Cuppel's Hall to incorporate a new village. It is said that Cuppel and Stutley I. Henderson made a deal with Allis Chalmers management to name the new village in honor of Edward P. Allis. The east-enders led by Cuppel, William Shenners, and Arthur McGeoch began the meeting early, and in five minutes time, named the village "West Allis." They also elected a governing board, called for a census, and mapped the bounds of the village, all to the consternation of the west-enders, who favored retaining the village name as North Greenfield.

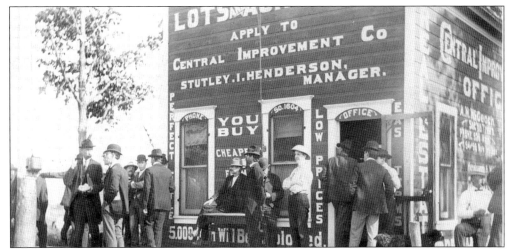

CENTRAL IMPROVEMENT COMPANY, C. 1909. After the meeting of incorporation for the Village of West Allis, an exact delineation of borders was necessary. Central Improvement Company was chosen to draw up the map. Central Improvement Company was owned by a consortium of land agents, most notably the Henderson Brothers, William Shenners, and Alexander McMicken. This company brokered the land deal with Allis Chalmers. They also held more land near the factory and platted out over 200 home-sites, many of which were covered with new workman's homes by the end of 1903.

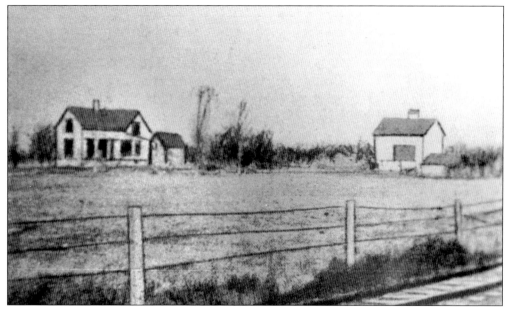

WHITTEMORE FARM, C. 1898. The Whittemore Farm was the main site under consideration by the Allis Works management. It was neatly sandwiched between the Chicago and Northwestern Railroad and the Chicago, Milwaukee, and St. Paul Railroad. Both agreed to build a belt line to serve the factory. The site was also easily accessible via the street car lines on National Avenue and at South Seventieth Street. The Allis Works management bought just over 100 acres for the price of $250 per acre.

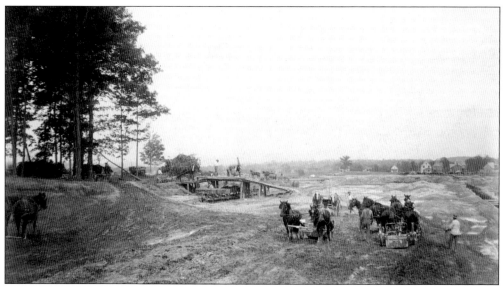

CLEARING LAND FOR THE ALLIS CHALMERS PLANT, 1901. By the time the land deal was sealed, the Allis Works merged with three other companies to become the Allis Chalmers Company. Work to clear the land started immediately in the spring of 1901. Manpower, horsepower, and gentle assistance from a railway locomotive cut brush, leveled the land for construction, and moved away the waste soil. By the end of 1902 the first offices and shops were ready to be occupied. (Photo courtesy of the Milwaukee Public Museum.)

Two

INDUSTRIAL CAPITAL OF WISCONSIN

One simple land deal jump-started the incredible industrial and residential growth of West Allis. A cascade of industries followed. Joining Allis Chalmers and West Allis' first industry, Rosenthal Corn Husker Company, were Kearney and Trecker, Pressed Steel Tank Company, Prescott Steam Pump Company, Kempsmith Company, West Allis Malleable Iron and Chain Belt Company, and Radcliffe Manufacturing Company. The presence of these and other companies later in the century changed the complexion of West Allis. The town grew as more labor flooded into the factories, much of that labor was made up of new immigrants from Central and Southern Europe. By the 1920s over 60 industries and manufacturing facilities called West Allis home. The *Evening Wisconsin* newspaper in June, 1903, recognized West Allis as an early industrial center calling it, "One of the great manufacturing centers of the Northwest."

WEST ALLIS INDUSTRY POSTCARD, C. 1950.

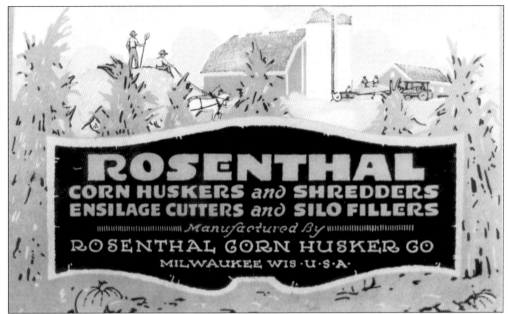

CATALOG COVER, ROSENTHAL CORN HUSKER COMPANY. Rosenthal Corn Husker Company, a manufacturer of agricultural machinery, was founded in Milwaukee in 1889 by brothers William, Henry, Gustav, and Carl Rosenthal. The company bought four acres of land in North Greenfield along the Northwestern rail spur to State Fair Park. They occupied the plant in December of 1901. It operated under family control until going out of business in 1955. The Rosenthal families lived near South Ninetieth Street at Lapham and were an integral part of the community.

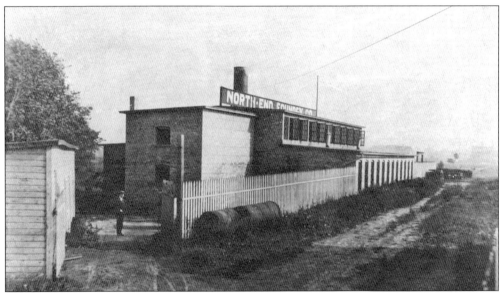

NORTH END FOUNDRY, C. 1913. The North End Foundry was originally established on the north end of the City of Milwaukee (on Green Bay Avenue) in 1906. After a fire destroyed the Milwaukee plant in 1913, the management moved the facility to West Allis, taking up a prime position near Allis Chalmers along the Chicago and Northwestern Railway beltline. They specialized in grey iron castings.

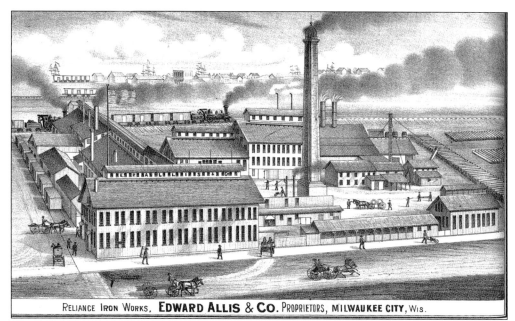

RELIANCE IRON WORKS, **EDWARD ALLIS** & CO. PROPRIETORS, MILWAUKEE CITY, WIS.

THE RELIANCE WORKS OF THE E.P. ALLIS COMPANY, C. 1876. This factory on Milwaukee's lower south side was taken over by Edward P. Allis in 1869. Allis enlarged and improved the factory, but the factory was totally landlocked by the time of his death in 1889. Superintendent Edwin Reynolds sought new land to again expand the factory. Reynolds and Allis' sons, Charles and William, settled on buying land in Greenfield Township in 1901. (Photo courtesy of the Milwaukee Public Museum.)

DETAILED VIEW OF THE ALLIS WORKS AND ALLIS STATION, C. 1909. This view demonstrates the cramped quarters of the original Reliance Works, now called the Allis Works. It also details the position of Allis Station. One naming story for the City of West Allis asserts that the name was imposed by the railroad, Chicago and Northwestern. It seemed the railroad could not have two Allis Stations, so the Chicago and Northwestern Station near the Allis Chalmers plant was called the "West" Allis Station. (Photo courtesy of the Milwaukee Public Museum.)

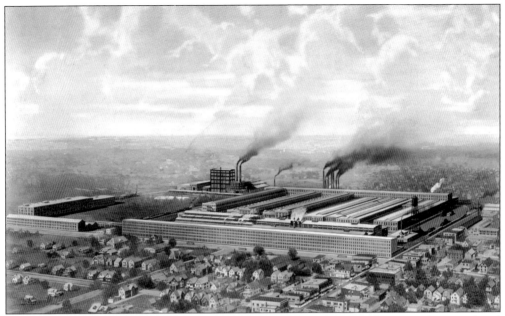

THE ALLIS CHALMERS COMPANY, C. 1910. By 1910, the great manufacturing plant employed thousands of skilled and semi-skilled workers many of whom bought homes in West Allis, forming the nucleus of a labor oriented, middle class community. This was a trying time for the company; mismanagement was driving it to the brink of failure. In 1913, local industrialist and militia officer, General Otto Falk (d. 1940), returned the company to financial stability and truly made Allis Chalmers the leader in mining, milling, lumbering, agricultural, and steam turbine manufacturing.

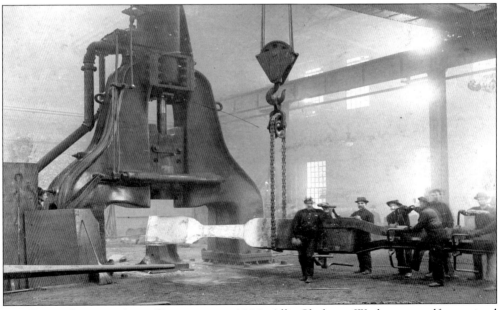

THE FORGE SHOP AT ALLIS CHALMERS, C. 1920. Allis Chalmers Works was a self-contained industrial community with a number of divisions providing services and materials for the giant assembly shops. Typically, early 20th century factories were built this way in an attempt to control manufacturing costs and product quality.

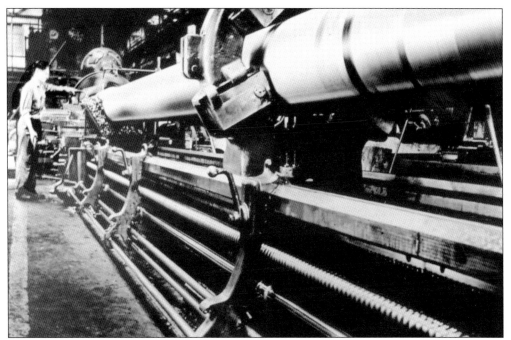

ROUGHING LATHE IN SHOP NO. 2 1/2, C. 1943. Allis Chalmers (simply known as A-C) was essential to war production. During World War I, A-C produced cannon projectiles, naval gun mounts, and steam engines for the government. During World War II, A-C produced propeller shafts (like the one on this lathe), torpedo casings, projectile casings, and a number of parts for the atomic bomb. A-C employed over 35,000 people during the war.

THE ALLIS CHALMERS CLUBHOUSE, CORNER OF SOUTH SEVENTIETH STREET AT MADISON. This is the second incarnation of the clubhouse. The original building, built in 1906, burned in a fire in 1918. This building was built in the manner of a southern plantation. Initially the clubhouse was for the use of Allis Chalmers' all male management. During World War II, the workers and women were allowed to eat in dining facilities separate from the management. In the 1950s the clubhouse was often lent to local high schools for their post-prom parties each spring. The clubhouse was turned into a restaurant in 1989 after A-C closed the factory. In 1997 the restaurant left the site, and the building was demolished.

FRANK (GUS) GSCHEIDLE, C. 1920.

MANHATTAN PROJECT "THANK YOU" LETTER, 1945. Frank Gscheidle was an employee of the Allis Chalmers Manufacturing Company for 50 years. He began with the plant in Scranton Pennsylvania in 1904, transferring to West Allis in 1912. He worked a variety of jobs, ascending to foreman in 1941 and security agent at the Hawley Plant (on the northeast end of the A-C grounds) where parts for the atomic bomb were made and assembled. In August 1945, he and other A-C employees who worked on the Manhattan Project received a nondescript letter of thanks from the government. Gscheidle finished his career with Allis Chalmers in 1954 and is a typical example of A-C's family of long-term employees. (Photos courtesy of Marty Hren.)

```
                                                            8 August 1945

TO THE MEN AND WOMEN OF MANHATTAN DISTRICT PROJECT:

        Today the whole world knows the secret which you have
helped us keep for many months. I am pleased to be able to
add that the warlords of Japan now know its effects better
than we ourselves. The atomic bomb which you have helped to
develop with high devotion to patriotic duty is the most de-
vastating military weapon that any country has ever been able
to turn against its enemy.

        No one of you has worked on the entire project or known
the whole story. Each of you has done his own job and kept his
own secret and so today I speak for a grateful nation when I say
congratulations and thank you all.

        I hope you will continue to keep the secrets you have
kept so well. The need for security and for continued effort
is fully as great now as it ever was.

        We are proud of every one of you.

                                        /s/ ROBERT W. PATTERSON
                                            Under Secretary of War
                                            Washington, D. C.
```

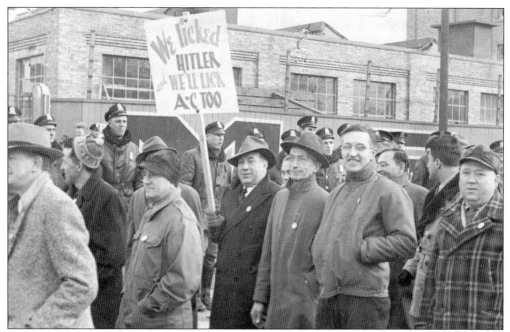

ALLIS CHALMERS STRIKE, FALL 1946. World War II was over, and the A-C craft unions reasserted their desires for proper work conditions and fair treatment of workers. A-C workers began their labor organizations in 1933, fighting almost annual battles with management throughout the 1930s. The 1946 strike was particularly bitter, lasting 11 months. Labor actions continued until A-C closed its doors in 1988, with the last battles over the safety of retiree benefits.

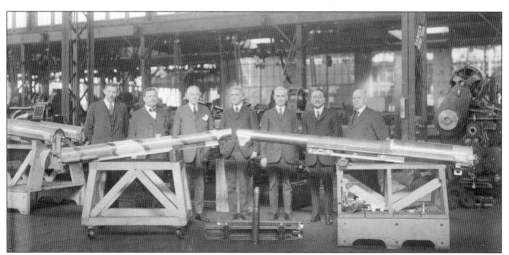

KEARNEY AND TRECKER COMPANY SENIOR STAFF WITH 75MM CANNON BARRELS, 1918. Kearney & Trecker (also called K-T) was incorporated in Milwaukee in 1898 by Edward Kearney and Theodore Trecker. After West Allis became a fashionable destination for growing industries, K-T moved to a new facility between Greenfield and National Avenues, across from Allis Chalmers along the railroad beltway. K-T was well known as a manufacturer of metal milling machinery. During World War I, K-T manufactured cannon barrels and other war material. Theodore Trecker (second from right) was involved in West Allis politics, serving as village president in the early days of the village.

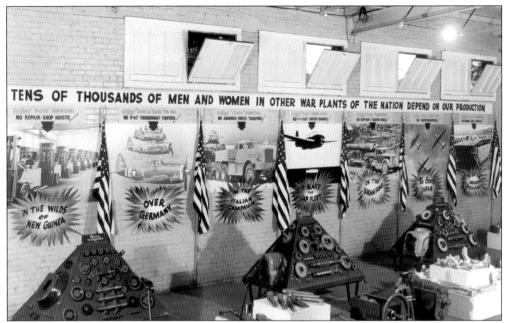

KEARNY AND TRECKER WORLD WAR II DISPLAY, 1944. K-T prepared an exhibit of manufactured goods that were used in the war effort. Automotive components, mainly vehicle transmissions, and aircraft parts dominated production.

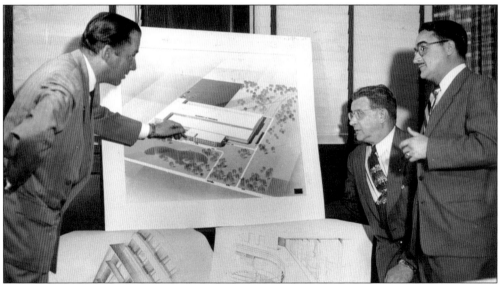

BROOKS STEVENS PRESENTS PLANS FOR A NEW KEARNEY & TRECKER PLANT, C. 1950. Company president, Francis Trecker, looks on intently as nationally prominent industrial designer Brooks Stevens presents plans for a new plant. The Greenfield Avenue plant was landlocked, and the facility needed upgrading. Trecker, committed to West Allis, built the new plant on Greenfield Township lands on Highway 100, six blocks north of Greenfield Avenue, still in close proximity to his West Allis workers. The plant was soon to be in West Allis again as the city, in 1954, would annex over six square miles of Greenfield Township, all the way to the Waukesha County border and including the K-T plant.

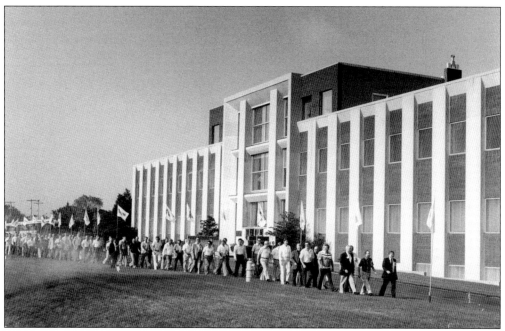

KEARNEY & TRECKER'S NEW PLANT, C. 1961. K-T employees parade around the plant carrying corporate and country flags signaling K-T's international aspirations. This plant was completed in 1954 and used until K-T was absorbed by Giddings and Lewis Company in 1985. In 1995 Quad Graphics, an internationally prominent printing company, bought the plant and reopened it as a printing facility.

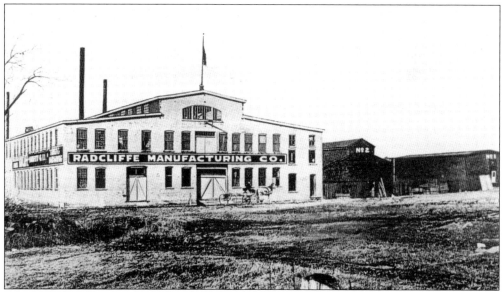

RADCLIFF MANUFACTURING COMPANY, 1909. Organized in 1901 in the City of Milwaukee by James Edward Radcliff, the company moved to West Allis in 1904, occupying two acres at South Sixty-sixth Street and Mitchell Street. The company specialized in millwork, window sashes, and door-frames. The owners closed the factory and sold the facility to Gerlinger Casting Company in 1919.

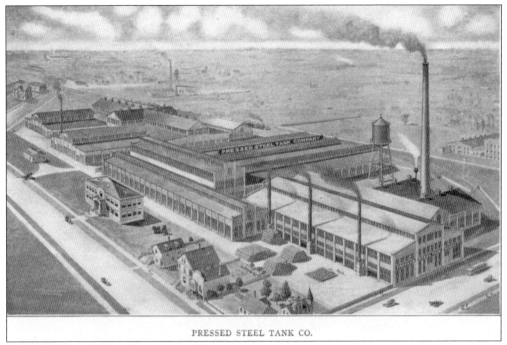

PRESSED STEEL TANK COMPANY, 1902.

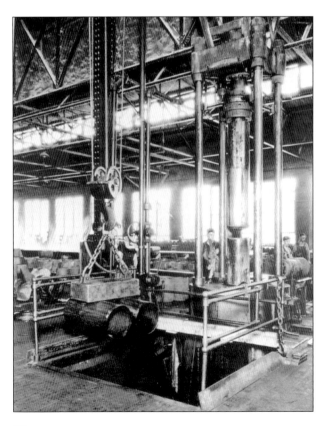

DRAWING A HIGH-PRESSURE CYLINDER. Pressed Steel Tank Company is considered a founding industry in West Allis. To this day they occupy a site at South Sixty-fifth Street, between Greenfield and National Avenues. The company specializes in making high and low pressure steel cylinders for gas, chemicals, and liquid applications. They also manufactured supplies for the auto industry and the US Government.

THE FULTON CORPORATION. The Fulton Corporation was established by Samuel A. Fulton (b. 1877) in West Allis in 1913. The company was on the cutting edge of the infant automobile industry, supplying horns, accelerators, and tools to the automobile manufacturers and repair shops

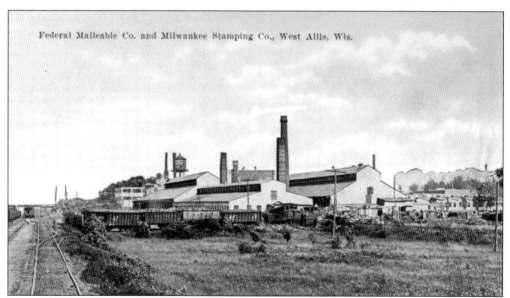

FEDERAL MALLEABLE IRON COMPANY, C. 1920. The company was known as West Allis Malleable Iron and Chain Belt Company and was founded in 1902 by O.L. Hollister. They were well-known for iron castings and chain link belts for the mining and smelting industries. In 1911 the Federal Malleable Company bought the plant and immediately doubled its area and production capacity. During World War I the company made hand grenade casings and tracks for early tanks. By the 1950s the company expanded production to include agricultural implements, automobile parts, and railroad equipment. The factory closed in the mid-1970s.

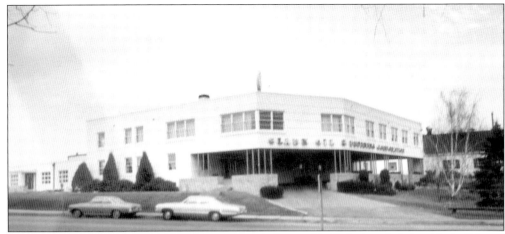

CLARK OIL AND REFINING COMPANY, C. 1975. Emory T. Clark founded the Clark Oil and Refining Company in 1932. Clark was a manufacturer and distributor of refined oil products at the retail consumer level. The company maintained and operated scores of service stations throughout the area. While the company is no longer located in West Allis, remnant service stations can still be found in the greater Milwaukee area.

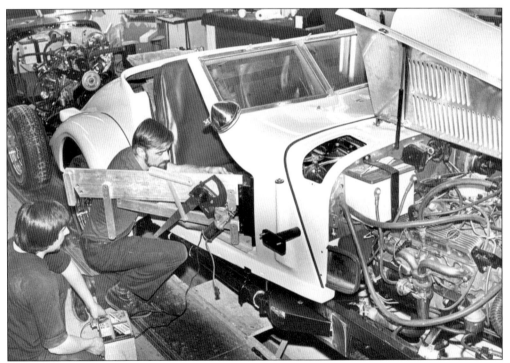

THE EXCALIBUR MOTORCAR COMPANY, C. 1982. Excalibur Motorcar Company manufactured their classic autos in the Milwaukee area for many years. The first Excalibur was designed in 1952 by Brooks Stevens who based the car on the classic style of 1920s Mercedes Benz sportscars. In the early 1980s the company came to West Allis and was located on Highway 100 just south of Greenfield Avenue. The company specialized in building high-end classically designed automobiles with Chevrolet motors and drive trains. Excalibur automobiles were the only hand-built car in America. The company left West Allis in the mid-1990s.

Three

MAKING A NEW CITY

The City of West Allis was planned as a 20th-century industrial city by the early land company agents and industrialists. Adequate space was set aside for industrial growth and even more space was set aside for workers' housing and all the businesses necessary to support the community. New immigrants and skilled laborers from the Milwaukee factories that relocated to West Allis swelled the newly platted neighborhoods. The old North Greenfielders profited by selling portions of their farmlands and by establishing businesses that catered to the expanding housing market. The homes and industries of the area required solid infrastructure to grow. New roads cut through old farm fields, city water was extended to the new community, and sewers were built. Street car and interurban train service snaked through and around the city. Fire and police protection was established very early in the life of the city and new schools quickly supplanted the one-room school house. The City began a series of annexations (1912, 1924, 1931, 1954) of township lands, increasing land area, population, and civic obligations, while protecting itself from encroaching annexation from the City of Milwaukee. Today, with all the township lands gone, West Allis and all communities in Milwaukee County must live within the means of the established land holdings. Re-use and redevelopment of existing lands and buildings has taken on great importance.

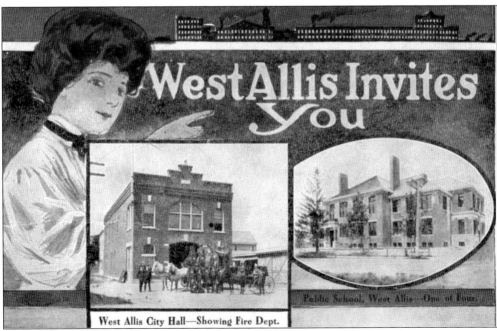

POSTCARD, "WEST ALLIS INVITES YOU," C. 1910.

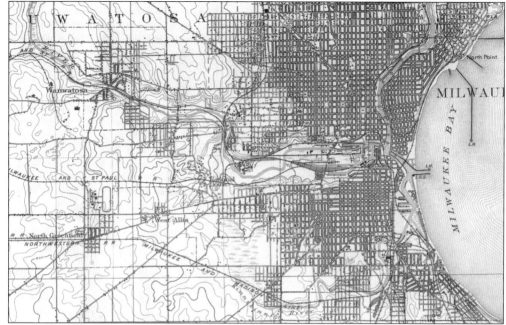

GEOLOGICAL SURVEY MAP OF CENTRAL MILWAUKEE COUNTY, 1909. This map depicts the relationship between Milwaukee, West Allis, and North Greenfield. In the details one can see the street level expansion of the city and villages. In 1909 West Allis was firmly established and North Greenfield still hung on as a named place on the map. This was due to the railroad maintaining the station name as North Greenfield. (Photo courtesy of the Milwaukee Public Museum.)

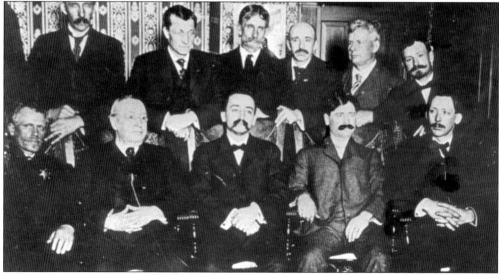

VILLAGE COUNCIL, APRIL 1903. In the second year of the village businesses grew rapidly along Greenfield Avenue and many new neighborhoods were platted. The Second Council took great pains to create the necessary roads for the movement of goods and people as well as attempting to obtain city water service from Milwaukee. In early 1904 this council negotiated the installation of electric street lighting. The earliest village council meetings took place at the Poiron Hall at South Eighty-first and National Avenue.

THEODORE TRECKER (B. 1868). Theodore Trecker was the co-founder of Kearney & Trecker Company, manufacturers of metal milling machines. Once the factory was located in West Allis, he took a great interest in improving the community. Trecker served as the second (1903) and fourth (1905) village president. During this time the population of West Allis more than doubled from 1,018 to 2,306 people. After his second term he returned to business life.

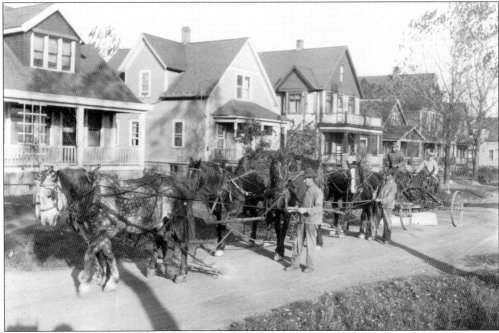

RAW HORSEPOWER, C. 1910. Streets were a major concern for the first two village councils. Dirt thoroughfares were common and needed constant attention. By 1912, West Allis had 55 miles of streets, of which only 1.5 miles were paved. By 1926, 60 percent of the streets were surfaced. Horse-drawn street graders like these were a common sight on city streets well into the 1920s.

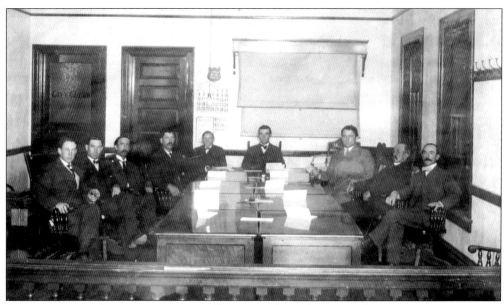

CITY COUNCIL, APRIL 1906. West Allis came of age this year when Wisconsin Governor J.O. Davidson proclaimed the village as a city of the fourth class. A new government was established of the mayor-council type with Frank Walsh elected mayor and two aldermen representing each of the four newly established city wards. Four policemen were hired, and a volunteer fire company was established. This was the first city government to occupy the first city hall built on donated land near South Seventieth Street and National Avenue.

MAYOR FRANK WALSH. Frank Walsh came to West Allis about the time the great Allis Chalmers Works opened. He established a cement works and built the first brick building on Greenfield Avenue. Walsh was West Allis' first mayor, serving multiple terms from 1906 to 1912.

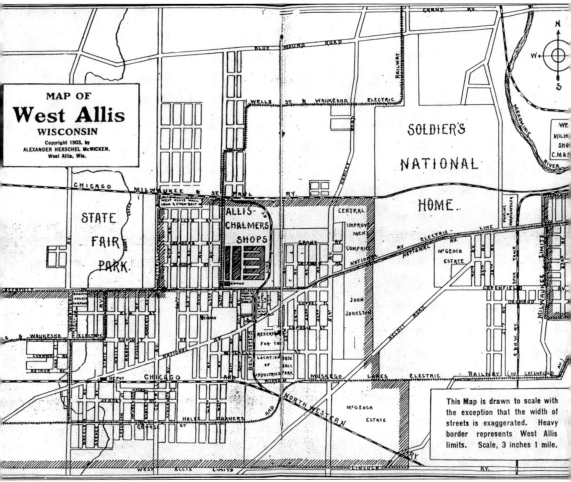

1903 Map of West Allis. This map, published in the 1904 city directory, depicts the boundaries as defined by the City Charter of April 12, 1906. Though many of the streets have different names, it is simple enough to determine the main thoroughfares of Greenfield Avenue and National Avenue. Cottrill Avenue is modern South Seventy-sixth Street. Woodlawn Avenue is modern South Ninety-second Street. Hawley Road is today's South Sixtieth Street.

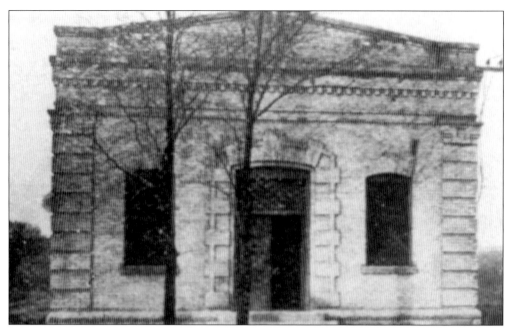

THE WATER PUMPING STATION, 1906. This was one of the first civic improvements undertaken by city government. This building occupied a lot on the city's east end on National Avenue. Water mains extended from the pumping station, up National and Greenfield Avenues, and branching off on Seventy-sixth, Eighty-first, and Eighty-second Streets.

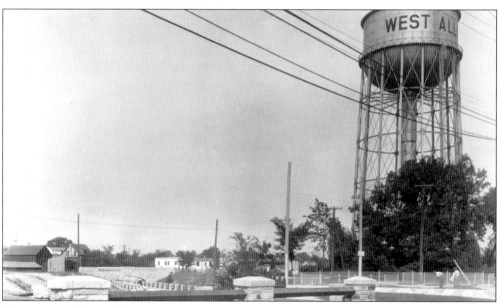

WEST ALLIS WATER TOWER AT HONEY CREEK PARK, C. 1936. As the City expanded it was difficult to maintain constant water pressure to businesses and residences. This tower, built in 1929, was a reservoir and gravity pressure vessel that boosted and regulated water pressure for buildings that were farther away from the pumping station. By 1927, 95 percent of West Allis homes had inside water and toilet facilities and were connected to the city sewer lines. In 1959, the city built a massive underground reservoir near South Ninety-second and Lapham.

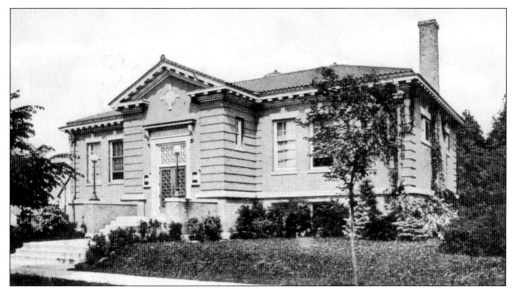

THE CARNEGIE LIBRARY. The first library was established in 1898 by the women of the North Greenfield Literature and Arts Club (later known as the West Allis Women's Club). The library, having no building of its own, operated from temporary, donated space in local shops. In 1912, the library board secured a grant of $15,000 from the Carnegie Foundation and built this structure on South Seventy-fifth Street and Orchard. An additional $1,000 filled the library with books. This building served the community from 1914 until early 1989.

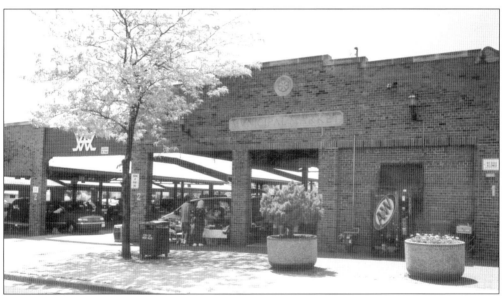

THE WEST ALLIS MUNICIPAL MARKET, "THE GREEN MARKET." In 1917, the city authorized the creation of a Market Commission that would oversee the construction and management of a new farmer's market. Land was bought in 1919 at the junction of National and Greenfield Avenues in the "Triangle." In 1931, after four years of argument, the market was moved to South Sixty-fifth Street at National Avenue. By 1935, it had 154 stalls, a brick shed, and an enclosed façade on the National Avenue side. This market was extremely popular, drawing farmers and customers from all over the Milwaukee area and surrounding counties. (Photo courtesy of the author's collection.)

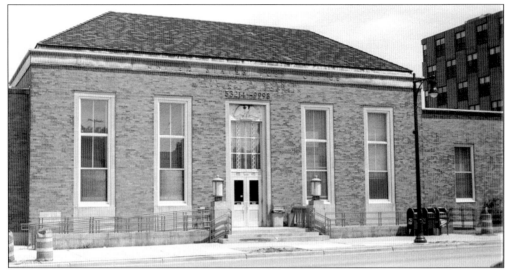

WEST ALLIS POST OFFICE, WEST GREENFIELD AVENUE AT SOUTH SEVENTY-FIFTH STREET. The West Allis Post Office was proposed as a permanent home for the West Allis postal branch in the late 1920s. It was finally opened in 1931 during the administration of Mayor Del Miller. The building contains some interesting art murals made by the WPA Artist's Program (1934–1939). As West Allis grew and annexed more land, two more post offices, the Fairview (south) and Root River (west) branches, were absorbed. In the mid-1990s, the Fairview branch was merged with a Milwaukee branch to form the West Milwaukee branch post office. West Allis is covered by three zip codes, 53214, 53219, and 53227. (Photo courtesy of the author's collection.)

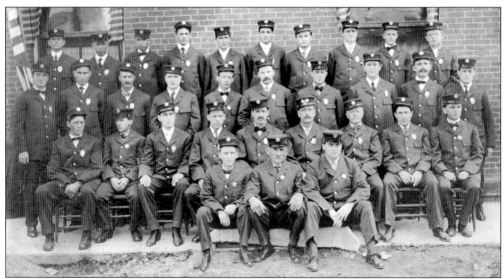

WEST ALLIS VOLUNTEER FIRE DEPARTMENT, 1906. With incorporation, the new City of West Allis established a volunteer fire department. The department was provided with fire protection equipment purchased in 1905: two hose carts, a combination truck, a chemical truck, a hose wagon, and 2,000 feet of two-and-a-half-inch hose. The fire department was an all volunteer department until 1922 when five full-time firemen were hired to maintain equipment and be first responders, getting the equipment to a fire scene where they would be met by the volunteer component. In 1925, the department staff consisted of full-time firemen.

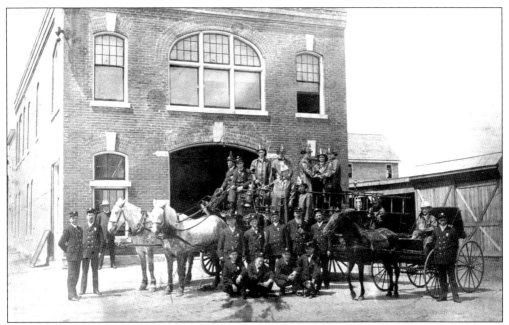

WEST ALLIS FIRE DEPARTMENT AND CITY HALL, 1907. The West Allis Fire Department proudly shows off its equipment and new home. The land for the building was donated in August 1905 by the Central Improvement Company in anticipation of the needs of the new city. The city fathers decided the building should be a multi-use building and had the design include a council chamber, vault, and office for the city clerk on the second floor. Construction began in March 1906 and was completed by September.

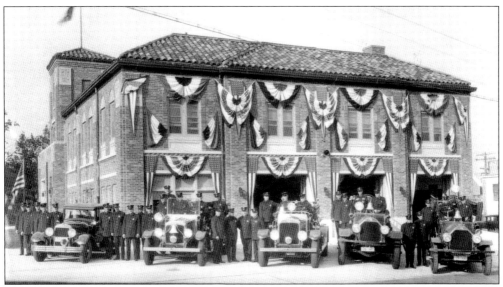

WEST ALLIS FIRE DEPARTMENT, 1930. The fire department moved from the old city hall to its own headquarters in 1930. In this picture the new fire station is decked-out for its dedication. This station served all of West Allis until the mid-1950s, when newly annexed districts created a need for increased fire protection. Station Two, near Becher Street, serves the southeastern part of the city, and Station Three, near Highway 100, serves the west end.

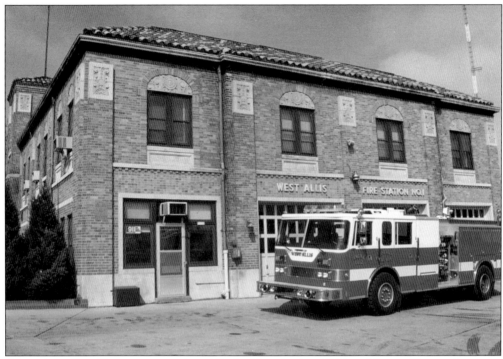

WEST ALLIS FIRE DEPARTMENT, 1993. The building, built in 1930, still houses Engine Company One, but only until the new central fire station opens in the fall of 2003. This building, designated a local landmark, will house the fire department administration and training programs.

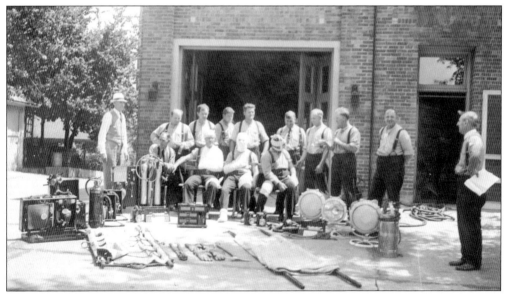

FIRE RESCUE SQUAD, 1937. Practice makes perfect, and the West Allis Fire Department knows how to practice. Here, members of the department practice first aid measures necessary to treat persons injured by fire and accident. These men, with their specialized training, were the precursor to today's paramedics. The department currently operates two fire rescue companies, one paramedic unit, and a technical rescue team.

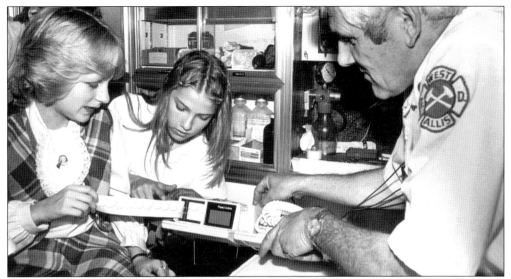

PARAMEDIC LIEUTENANT DON LIEDLE DEMONSTRATES AN EKG MACHINE, 1981. In 1973, the West Allis Fire Department was the first department in Milwaukee County to train selected firefighters as paramedics armed with advanced life-saving equipment. Initially some in the community were unsure of the need for such services, but over the years the paramedics have proven to be an essential part of West Allis life. So much so, that repeated financial support from West Allis Charities, local business, and concerned individuals has made the West Allis paramedics the best trained and best equipped squad in the area.

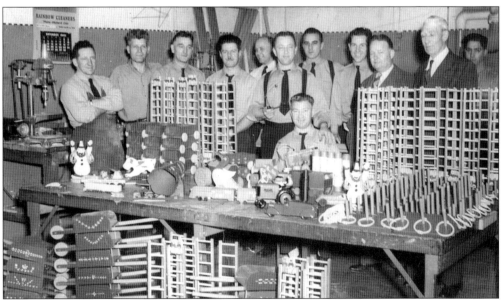

FIREFIGHTERS BUILD TOYS FOR UNDER-PRIVILEGED YOUTH, 1945. West Allis firefighters are a generous and concerned lot with community needs at heart. Over the years the firefighters have been involved in a number of educational and charitable endeavors. Most recently juvenile fire safety programs have become a priority. The West Allis Fire Department established the first "Survive Alive" house in Wisconsin in1985 to train children in fire safety techniques. Firefighters are also involved in the Child Abuse Prevention Fund and the Muscular Dystrophy Association.

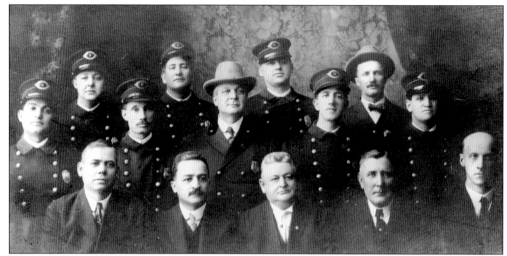

WEST ALLIS POLICE DEPARTMENT PORTRAIT, 1913. West Allis' first police force was appointed in 1906 with a complement of four paid officers. By 1913, Chief Samuel Minturn (center) had seven officers and the support of a new Police and Fire Commission, established in 1910, and the judges of the police court. At that time officers worked 12-hour shifts every day of the year, received 10 vacation days, and were paid $75 per month. The police department shared space at the Village Hall with the fire department and city government.

RAPID RESPONSE, 1926 STYLE. The police department increased its response time to calls with the addition of a Lincoln touring car, A Nash ambulance, a patrol wagon, two Ford patrol cars, and three Harley Davidson motorcycles. By the 1950s, the department operated eight squad cars, five motorcycles, an ambulance, a patrol wagon, and a station wagon/ambulance, all radio equipped. The 1952 police force had 40 patrolmen, six detectives, nine desk officers, and seven commanding officers.

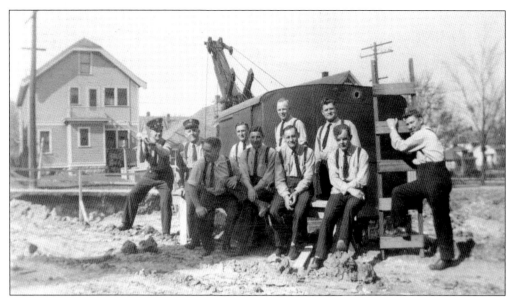

OFFICERS ANTICIPATE A NEW HOME FOR THE POLICE, 1937. By 1934, the police department had outgrown the meager space they had at the old City Hall. Chief Sam Minturn and his successor, Chief Thomas Kastello, had the station designed with the convenience of the officers in mind by the architectural firm of Ebling & Plunkett. It is easy to see why these men are so happy to help the steam shovel along in its work.

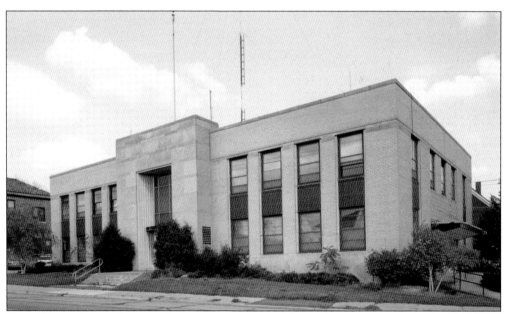

THE WEST ALLIS POLICE STATION, C. 1970. The police station and administration building was opened in 1939. The first floor held offices and cells. The second floor was occupied by the municipal court. The late "Art Moderne" style building was remodeled in 1959 to add more office space. By the 1970s, even more space was needed, and the municipal court moved out. The growing police department would struggle with this space until 1995. The 1939 police station was demolished in 1997.

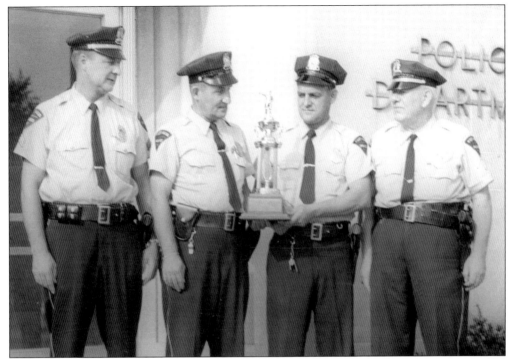

THE 1959–1960 POLICE MARKSMANSHIP TEAM. Officers stand outside the entrance to the police station to admire their trophy from the Milwaukee County Police League. Pictured left to right are Officers Miles Cleppe, Ed Bohn, Clarence Long, and Herb Draeger.

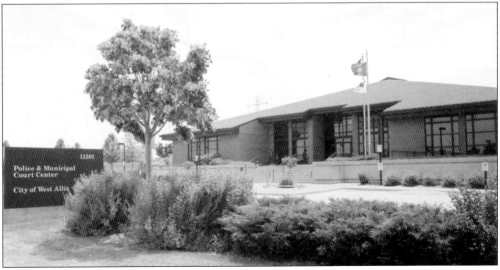

MUNICIPAL COURT AND POLICE CENTER, 2003. Together again, the municipal court and police department now share a large, improved facility at 113th and West Lincoln Avenue. This facility was opened in 1995. (Photo courtesy of the author's collection.)

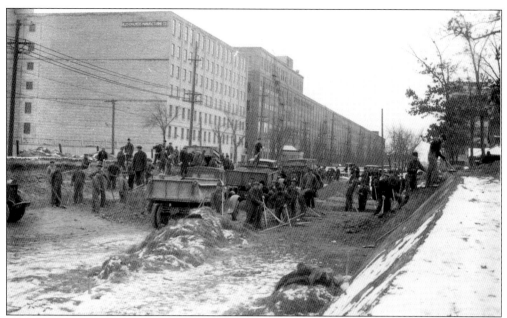

STREET CONSTRUCTION BY WPA WORKERS, SOUTH SEVENTIETH STREET NEAR ALLIS CHALMERS.

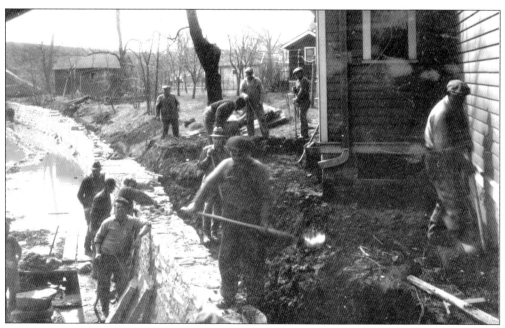

CHANNELIZING HONEY CREEK. West Allis was not immune to the effects of the Great Depression. Many men lost jobs in the factories and some families suffered very difficult times. In 1932, the City of West Allis joined the growing list of communities putting people to work under the auspices of the Federal Works Progress Administration (WPA). Most projects centered on civic improvements and heavy construction; street building and repair and construction of schools and civic buildings were common. A special project for West Allis was the channelization of Honey Creek, a flood control measure. (Photos courtesy of Barbara Hart.)

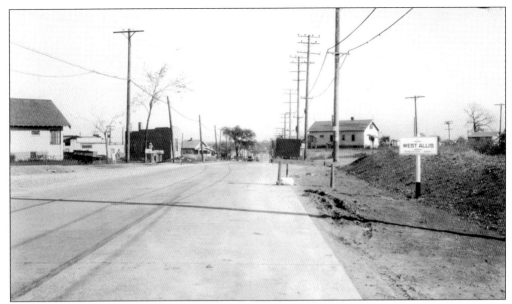

WESTERN CITY LIMITS, C. 1935.

NORTHERN CITY LIMITS, C. 1935. It wasn't until the 1950s that West Allis more than doubled its land area. In 1902, 2,400 acres contained the city. By the 1940s, expansion barely added an additional 1,000 acres, totaling nearly five square miles. In 1954, the annexation of township lands added 6.1 square miles to the city. Today West Allis is a mere 11.4 square miles, with a population of 62,000 people. These photographs show the western border at Lincoln and National Avenues and South Ninety-second Street, and the northern border at South Seventy-sixth Street and Pierce Street. The railroad is the LaCrosse Division of the Chicago, Milwaukee, and St. Paul (Milwaukee Road) that first came through the area in 1863. The depot to the left was built in 1906 to serve West Allis and the Allis Chalmers plant.

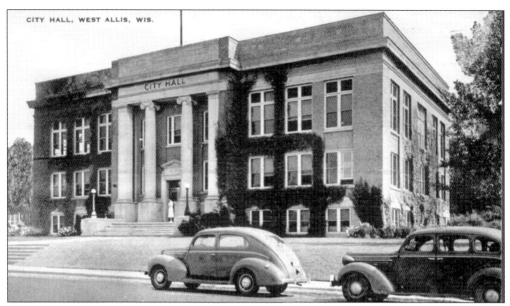

WEST ALLIS CITY HALL, C. 1940. The original City Hall was quickly outgrown. In 1919, construction began on the "new" City Hall, which was to be solely an administrative center. The building was opened in 1921 and stood on the corner of South Seventy-sixth Street at Greenfield Avenue. It was first occupied by the administration of Mayor Del Miller (mayor 1920–1932, 1936–1944).

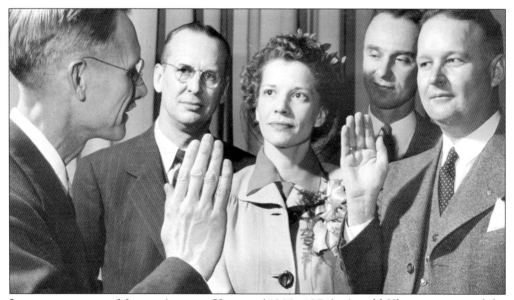

INAUGURATION OF MAYOR ARNOLD KLENTZ (1902–1971). Arnold Klentz was one of the most appreciated mayors the city has ever had. He came to West Allis in 1932 and worked in the newspaper business. He was extremely active in civic organizations, especially the Lions Club, and was a fierce defender of the City. Klentz is remembered as a man who truly cared for his community. He was sworn in as mayor on April 18, 1944 by City Clerk Fred Sanlader, with his wife "Billie" by his side. Arnold Klentz died in office in March 1971, having served the people of West Allis for 27 years.

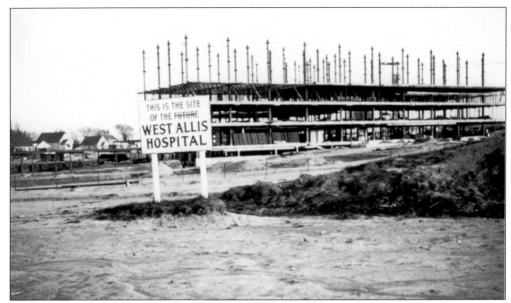

CONSTRUCTION OF THE WEST ALLIS HOSPITAL, C. 1959. The city wanted a hospital for its citizens as early as 1906, but it was not truly considered until the mid-1940s. By 1945, the city purchased 12 acres of land at South Eighty-ninth Street and Lincoln Avenue. It would be another nine years before further action would be taken. Four more years would lapse before ground was broken in July 1958.

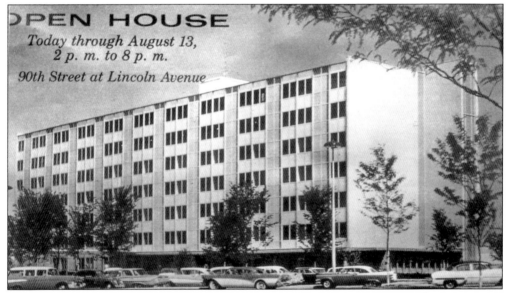

GRAND OPENING OF WEST ALLIS MEMORIAL HOSPITAL, AUGUST 1961. Great care was taken to insure that the new hospital would be the most technologically advanced and well-staffed hospital in the area. The city ran the hospital until 1963 when a voluntary board took over the management. Over the years additions were made to the lab and emergency medicine units, and a professional office building and parking garage were added in the 1970s. Aurora Healthcare Inc., managing the hospital since 1994, recently expanded the building with a women's healthcare pavilion.

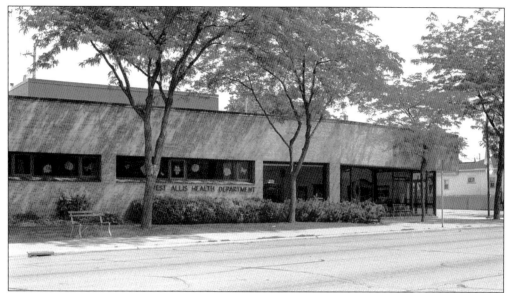

WEST ALLIS HEALTH DEPARTMENT. Edmund McCorkle was the first health officer for North Greenfield in 1902. From this simple beginning the city has made provisions for the overall health of the community. The Health Department has been responsible for basic health services, health education and programs, vital statistics, and the accuracy of weights and measures. This building, occupied by the department since 1979, is located at South Seventy-second and National Avenue. (Photo courtesy of the author's collection.)

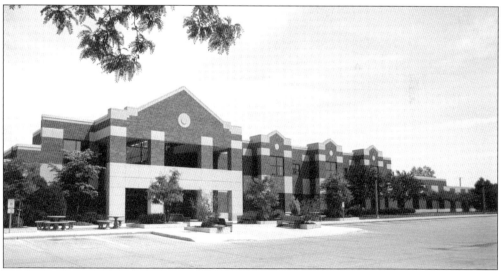

THE WEST ALLIS PUBLIC LIBRARY. Since 1898, the Library has had six homes. This grand structure is the latest. It was built in 1988 on the site of Warne Field, the old high school football stadium at South Seventy-fourth Street and National Avenue. Opening in 1989, this library consolidated the collections of the old main library and two branch libraries in a centrally located, modern structure. In true West Allis tradition, the library is governed by a nine-member citizen board. It is the largest suburban library in the Milwaukee County Federated Library System, with a circulation of 747,464 items and a collection of nearly 200,000 books. (Photo courtesy of author's collection.)

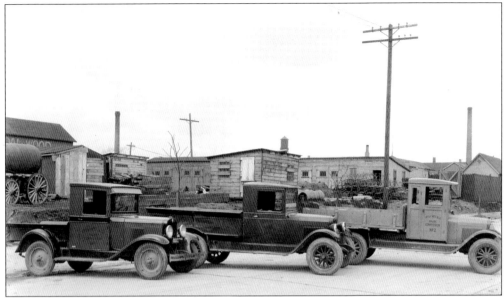

VEHICLES OF THE DEPARTMENT OF PUBLIC WORKS, 1929. In building a new city, the founders of West Allis were determined to maintain what they built. The first public works positions were established in 1907 for the collection of trash and maintenance of the new city water supply. The Department of Public Works is the arm of city government responsible for street maintenance and lighting, sanitation, park maintenance, city building maintenance, and water and sewer services.

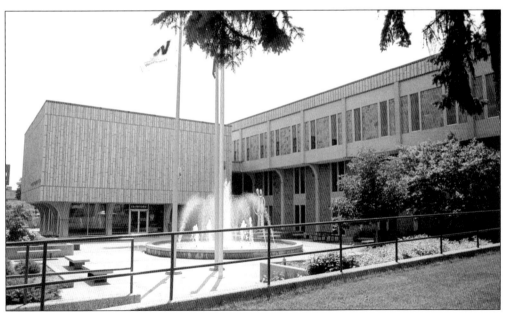

WEST ALLIS CITY HALL, 2003. To many West Allisans this building is still thought of as the "new" City Hall. Well, the "new" City Hall is now 33 years old. Ground breaking for the 41,000-square-foot building took place in 1967. Construction was completed, and the seat of our government was dedicated by Mayor Arnold Klentz in May 1970. The City Hall has a 3,000-square-foot council chamber and a 2,000-square-foot exhibition space in the basement level. (Photo courtesy of the author's collection.)

Four

BACK ON THE BLOCK
HOMES AND BUSINESSES

Neighborhoods are the heart of a city, and West Allis is no exception. From the Pioneer District, to Six Points, to the Burnham-Becher, Lincoln Avenue, and Parkway areas, West Allis is a mix of homes interspersed with small businesses. The oldest neighborhoods are near South Eighty-first Street at National, closely followed by the neighborhoods east of the Allis Chalmers plant, extending south to Burnham Street. These areas have much the same character and housing stock as is found in the City of Milwaukee with many frame single-family homes and duplexes on city sized lots. These neighborhoods were often heavily immigrant in make-up after 1900. Corner businesses and small business districts characterize this area. Farther south and west are the neighborhoods that grew up after World War II on the annexed farm lands of the township. These neighborhoods have larger lots and are predominantly single-family, ranch-style, and masonry homes. This area also accommodates a number of apartment complexes built since the 1960s. Shopping malls harbor the usual big-box stores and fast food restaurants. Since 1901, West Allis has been linked to the City of Milwaukee via the street car system and the interurban lines. Rubber-tired buses carried people around town beginning in the 1920s, slowly replacing the street car lines. The last street cars in West Allis ran in 1958 along the Burnham-Becher corridor. In the second decade of the 20th century automobiles were a curiosity, but grew into a major conveyance and symbol of suburban independence after World War II. And in the 1950s, the interstate highways ringed the city. From West Allis one can, for work or pleasure, access any place in the county with ease.

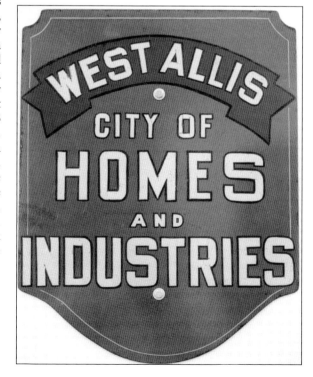

THE CITY OF HOMES AND INDUSTRIES. From the 1950s to the 1970s, signs like this greeted everyone who entered West Allis.

ARE YOU PAYING RENT?

Why not own a home of your own in this beautiful and growing suburb WEST ALLIS? A small payment down secures a lot in one of our centrally located subdivisions. Why put it off. Make a start toward providing for your old age. DO IT NOW.

One representatives on the premises week days or Sundays. No trouble to show property whether you buy or not.

Central Improvement Company

"Founders of West Allis"

MAIN OFFICE	BRANCH OFFICE
62nd and Greenfield Ave.	53rd and National Ave.
Opp. West Allis Bank.	At 5c fare limit.

THIS?

OR THIS?

"STAPHANGER" ADVERTISEMENT, CENTRAL IMPROVEMENT COMPANY, C. 1910.

RENTING — Phone West Allis 229 — **Juneau Hathaway Co.** — **INVESTMENT** — WEST ALLIS, WIS.

JUNEAU-HATHAWAY COMPANY ADVERTISEMENT, C. 1918. Real estate companies took advantage of the image of the crowded, unhealthy city as a hook to entice city dwellers and new immigrants to come to the relaxed, healthy, beautiful, and bountiful lands of West Allis. Central Improvement Company had lands near Allis Chalmers and all around the east end. Juneau Hathaway lands were between Burnham and Beloit Road, west of South Sixtieth Street.

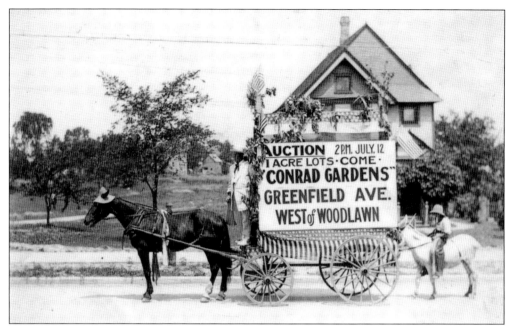

CONRAD GARDENS SUBDIVISION ROVING ADVERTISEMENT, C. 1910–1919. Lacking radio and television as an advertising medium, developers used many methods to get the word out about their properties. Land agent Otto Conrad had land mainly on the east, but extended his dealings westward to Conrad Gardens, located near Greenfield Avenue, west of South Ninety-second Street.

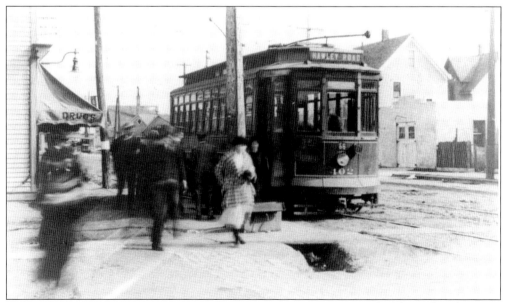

HAWLEY ROAD STREET CAR, C. 1918. Street cars like this were typical of the Milwaukee area. For many years they were the only way for people to reach the far-flung jobs and amusements of the county. Street cars were crowded, hot in the summer, cold in the winter, dusty, and oddly beloved by their riders and the neighborhoods they served. This photo is attributed as Hawley Road at National Avenue on West Allis' east end.

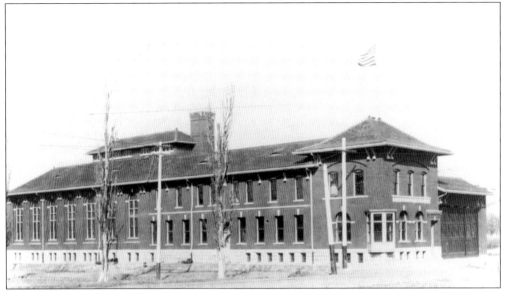

WEST ALLIS CAR BARNS, BUILT IN 1904.

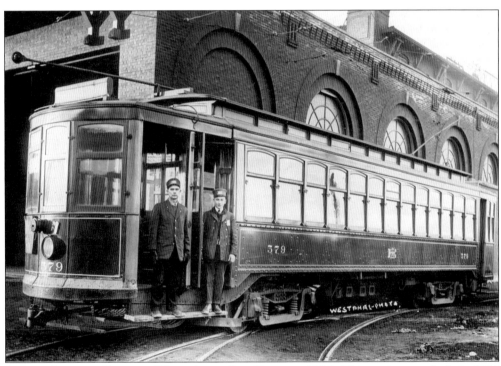

STREET CAR AND STAFF AT WEST ALLIS CAR BARNES, 1920. This station was built in 1904 to accommodate the transportation needs along South Eighty-fourth Street between West Allis, Wauwatosa, and the Wisconsin State Fair Park and on into Milwaukee. Building a car barn at West Allis saved The Milwaukee Electric Railway and Light Company money by eliminating crew costs associated with returning empty cars to other car barns at the end of a shift. Many conductors and crew moved to West Allis to be close to their work. The car barns were closed in 1955 and demolished in 1984.

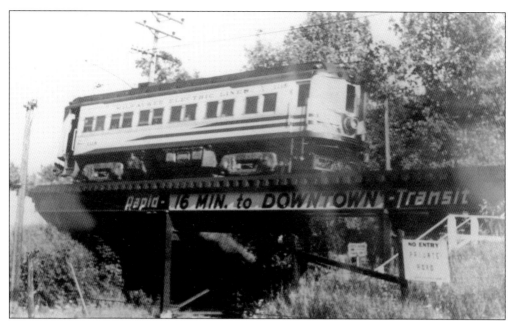

INTERURBAN CAR, C. 1930. Interurban trains ran in the Milwaukee area from 1896 to 1951. Until the 1920s, they shared the city streets with street cars, automobiles, horse drawn wagons, and pedestrians. The interurban trains were eventually put on their own right-of-ways, and upgraded trains made good speed from the suburbs and adjoining towns to downtown Milwaukee. Milwaukee was the hub of most activity, and it was still an important place for West Allisans to conduct their business with county and federal authorities and major merchants. The interurban above promised "rapid" 16-minute service to downtown.

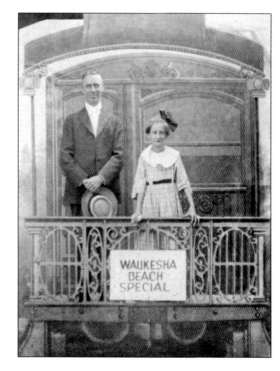

WAUKESHA BEACH SPECIAL, C. 1920. Waukesha Beach on Pewaukee Lake in Waukesha County was a popular summer destination for many people from Milwaukee County. It was accessible by train and by interurban car on lines that ran through West Allis. (Photo courtesy of Barbara Hart.)

WILBUR LUMBER COMPANY ADVERTISEMENT.

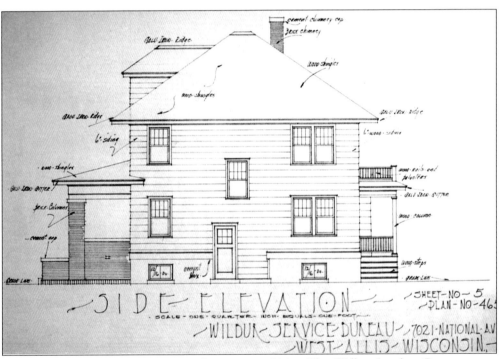

HOUSE PLAN BY WILBUR LUMBER COMPANY, 1920s. The Wilbur Lumber Company was founded in 1875 in Burlington, Wisconsin. The company moved to West Allis in 1922 at National Avenue and South Seventy-eighth Street. Wilbur was a full-service building supply company like many others in the area. What set them apart was residential architectural design. The company designed a number of "stock" homes that could be purchased as lumber and components and built on any site the customer chose. Wilbur Lumber Company closed in 1970.

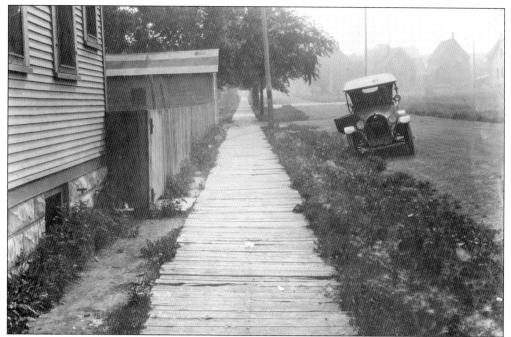

WOODEN SIDEWALKS, 1919. The older sections of West Allis were lined with wooden sidewalks. This walkway in William Shenners subdivision, east of South Sixtieth Street and north of National Avenue, shows the unevenness and problems of a wood sidewalk. In the 1920s, the city gave homeowners a tax incentive to repair the sidewalks. Maintenance was an ongoing issue and concrete sidewalks replaced many of them in the 1930s.

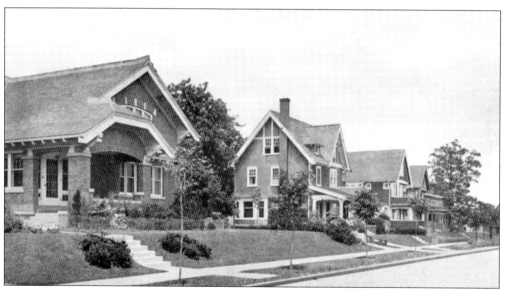

POSTCARD VIEW OF A WEST ALLIS RESIDENTIAL STREET, C. 1925. The 1920s were a real boom time for home building in West Allis. City pride in the new housing stock was so high that it was the subject of postcards like this. These homes are believed to be somewhere along South Seventy-fifth Street. Within a few years the Great Depression would almost halt West Allis' expansion and building programs.

HOME OF MAYOR FRANK BALDWIN, 1918. Local businessman and mayor (1912–1914 and 1918–1920), Frank Baldwin, stands outside his home near South Seventy-sixth Street and National Avenue. Handsome single family frame homes, like these, were the norm for most West Allisans. Over 90 percent of West Allis homes were owner occupied at this time.

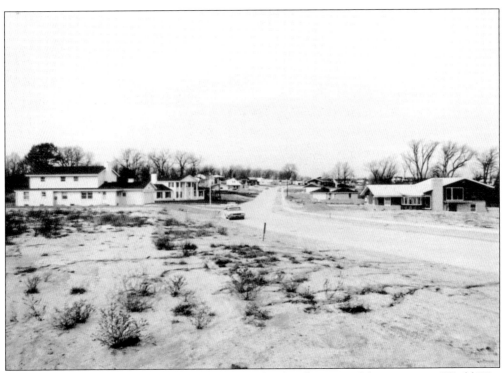

ORCHARD HILLS SUBDIVISION, MID-1950S. Orchard Hills is one of the many post World War II subdivisions built in West Allis. The land was formerly one of the Rust Brothers farms.

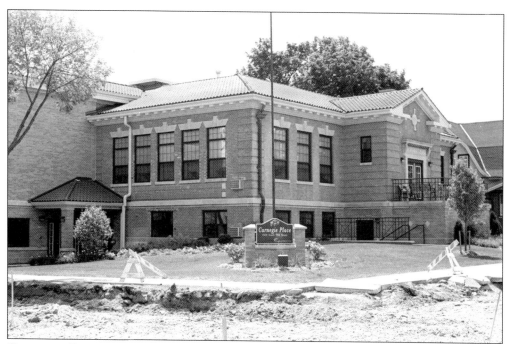

CARNEGIE PLACE APARTMENTS, 2003. This is the old West Allis Public Library's main library at South Seventy-fifth Street and Orchard Street. Today, land is at a premium in the city, and a growing appreciation for the old architecture prompts us to find ways to adapt and reuse old buildings. This building was refurbished and expanded to accommodate 14 senior-living apartments.

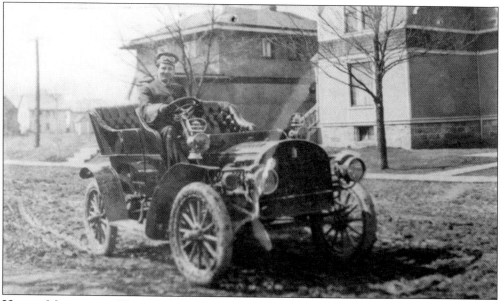

HENRY MEIGS AND HIS 1905 RAMBLER, 1906. Insurance agent and city official Henry Meigs shows off his Rambler on the streets of West Allis. In 1906 automobiles were quite the novelty. Note the dirt streets and all the protective clothing worn by Mr. Meigs. There were no paved streets at that time.

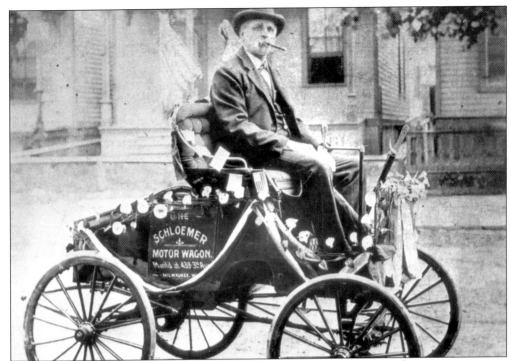

FAY CUSICK AND THE SCHLOEMER AUTOMOBILE, C. 1925. In the 1920s, Wisconsin's oldest automobile plied the roads of West Allis. Fay Cusick (1866–1935), lumber yard owner, automobile salesman, real estate developer, and city official bought the car from inventor Gottfried Schloemer, a resident of Greenfield Township, in 1920. According to oral tradition the car was built in 1890 in Milwaukee and presumably predates the Duryea Automobile (acknowledged as the world's first automobile) by two years. Cusick owned the car until 1930, often riding it in parades in the area. (Photo courtesy of the Milwaukee Public Museum.)

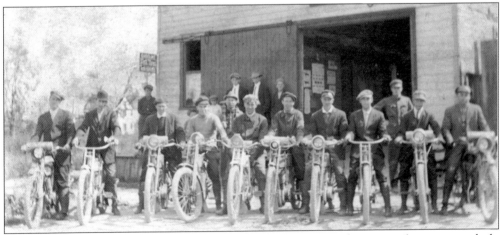

BLACKSMITH AND AUTO LIVERY, 1916. By the 1920s, cars and motorcycles were regularly seen on West Allis streets. As new housing and more people came to town, greater personal mobility was desirable. Existing businesses like blacksmiths adapted to meet the needs of the new machines. Many blacksmiths turned to auto livery services, gasoline distribution, and repair work, like Carter's Garage shown above.

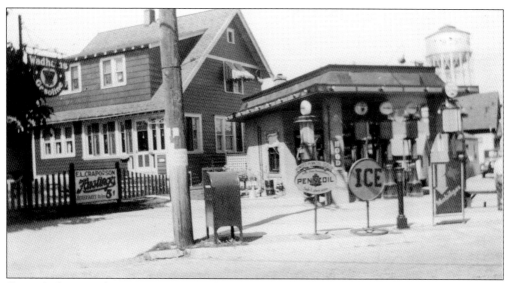

CRAPO'S SERVICE STATION, 1932. By the end of the 1920s, service stations sprang up in many neighborhoods. Often the owner lived in the same neighborhood as his business, taking a lively part in the life of the community. Ernest Crapo (1874–1942) opened this station at South Eighty-fourth Street and Becher Street in 1929 and was affiliated with the Wadham's Oil Company.

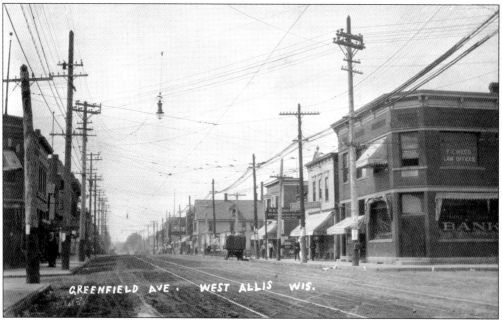

GREENFIELD AVENUE BUSINESS DISTRICT, C. 1920. In the beginning, National Avenue was the main business district of West Allis. Greenfield Avenue began as a mix of grocery stores and meat markets serving the people of the new subdivisions. More businesses joined Greenfield Avenue after T.J. Fleming convinced the street car company to run their track up Greenfield instead of National Avenue. Once Allis Chalmers Company located to West Allis, Greenfield Avenue filled with stores happy to serve the factory workers and the district quickly overshadowed the businesses of National Avenue.

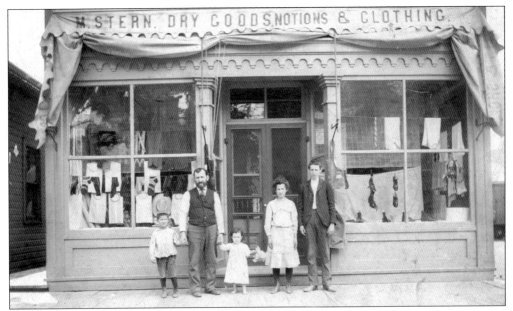

STERN'S DRY GOODS STORE, 1915. Max Stern (d. 1952) was one of the key businessmen of National Avenue. His dry goods and clothing store served West Allis for 50 years. He and his family lived behind the store at Eighty-first and National Avenue, but attended synagogue on Milwaukee's north side at Congregation B'nai Shalom. Stern was a founding member of the synagogue.

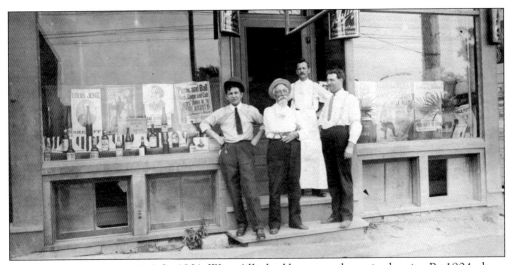

PHALEN'S SALOON, C. 1916. In 1901, West Allis had but two saloons in the city. By 1904, there were 17 saloons and inns stretching from Hawley Road to Eighty-fourth Street. Most offered beer and spirituous liquor and games of pool and cards. Many saloons were attached to certain breweries that supplied their beer, glasses, and advertising. Schlitz, Blatz, and Pabst breweries established their parlors throughout the area. Many of the saloons, like Phalen's saloon, were situated along Greenfield and lower National Avenue for two reasons: first, to serve the men of the factories; and secondly, much of the land of western National Avenue carried stipulations in their deeds on the land that forbade the sale of liquor. This was a legacy of a number of women landowners who were members of the temperance movement.

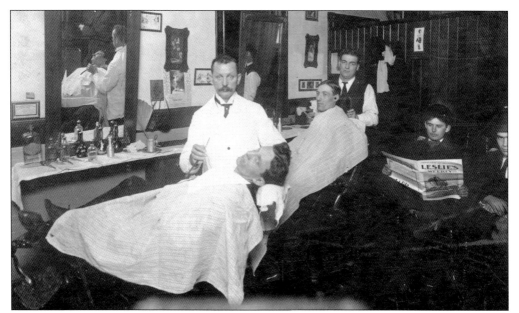

W.H. DAY'S BARBER SHOP, NATIONAL AVENUE, C. 1915. The barber shop was a community institution across America. Unlike many other businesses the barber shop was a place for men to congregate, exchange ideas, gossip, and share business news. Barber shops were also places of employment for the city's early African Americans who worked as valets and shoe-shine vendors. At the time of this photo there was but one black family in West Allis, today there are just over 800 African Americans living in the city who work in a variety of professional, technical, and service industries.

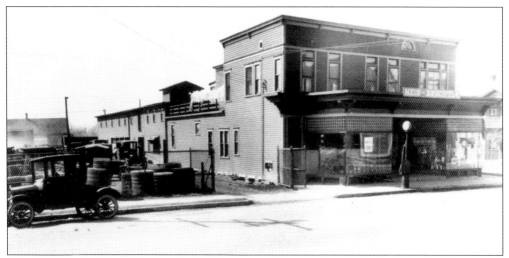

THE NEIS-FREUND HARDWARE COMPANY, C. 1910. The Neis-Freund Company took over the assets of the Smith Blodgett Hardware Store (est. 1903) in 1909. Over the years the store furnished the hardware for many major buildings in the area, such as the second City Hall, many of the local churches, and West Allis Memorial Hospital. The Neis Company (name changed in 1940) was one of the largest heating and plumbing suppliers in the county with a reputation for being able to get everything a builder would need. The company, located at Seventy-ninth and National, closed in 1999.

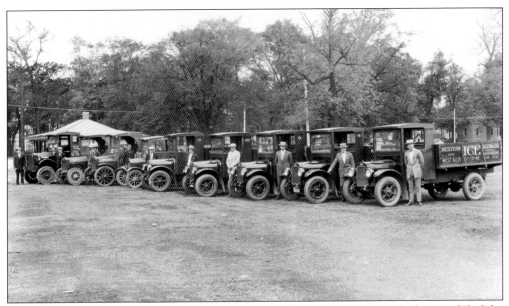

WESTERN ICE AND COAL COMPANY, LATE 1920S. Homes of the time relied on coal fuel for heating purposes and ice for refrigeration. Western Ice and Coal Company, located on South Eighty-first Street near Orchard Street, was one of a small number of companies, the others being diversified lumber yards that provided fuel to the area. Western was also a supplier of ice to the Wisconsin State Fair. Here the Western delivery fleet is shown at State Fair Park, with owner/founder Raymond Werner at the first truck on the right.

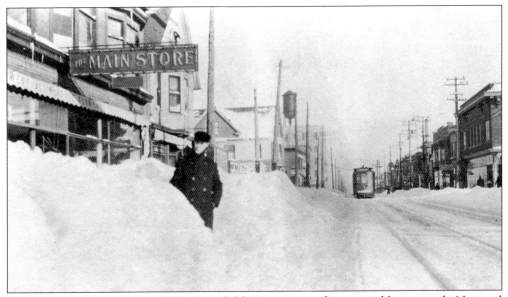

GREENFIELD AVENUE, C. 1915. Greenfield Avenue merchants quickly overtook National Avenue as the primary shopping district of West Allis. This view, looking east from Seventy-third Street, provides a view of Epstein's Main Store and the realities of Wisconsin winters.

DALIN'S JEWELRY STORE, C. 1915. Sam Dalin (1891–1973) opened his jewelry store on Greenfield Avenue in 1912. It was "the" place for West Allisans to shop for gifts, watches, and jewelry. Dalin was an active member of the community, a leader of the Kiwanis, and was a founder of the Downtown West Allis Association (1930). Dalin's Jewelry Store closed in 1984.

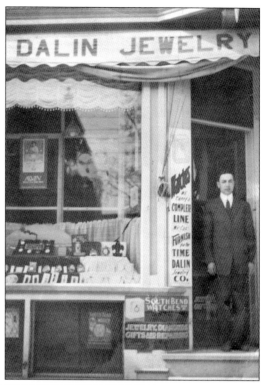

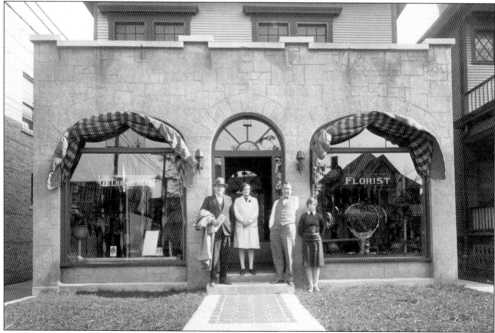

CHAMBERLAIN'S FLOWER SHOP, C. 1930S. Established in 1915, Chamberlain's Flower Shop is a perennial presence in downtown West Allis and the favorite place for local high schoolers to buy corsages and flowers for school dances and banquets. Here, Chamberlain family members pose outside the shop/home on Greenfield Avenue.

THE STORM OF '47, GREENFIELD AVENUE. In 1947, southeast Wisconsin was hit with a "perfect storm" that dumped nearly four feet of snow on the area. Street cars were stranded wherever they stood; some conductors refused to leave their cars and stayed with them for three days before relief came. City services were overwhelmed but continued to work through the storm and its aftermath. It took more than a week for the whole area to recover.

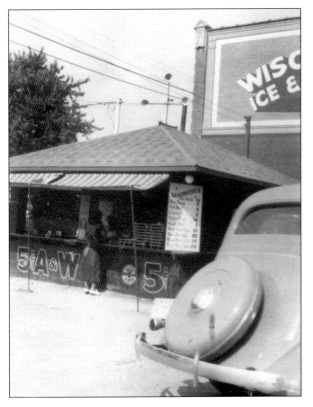

FLEMING'S A&W STAND, C. 1932. The Fleming family has been an important part of the development of West Allis. Tom Fleming was the man who convinced the street car company to use Greenfield Avenue as the approach to the Fairgrounds and sold real estate in Fleming Park subdivision. His son, Harold Fleming, began the A&W Root Beer business, across from State Fair Park at South Seventy-eighth Street, in 1931. The Fleming's were active in community organizations, the national organization for A&W franchisees, and the Holy Assumption Parish. The restaurant was a community favorite and is still remembered today, even though it closed in 1984.

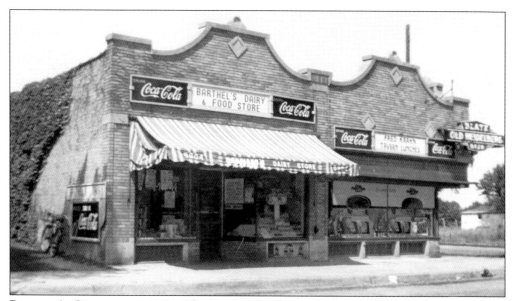

BARTHEL'S GROCERY, C. 1950. The Barthel family operated this grocery and dairy store on Greenfield Avenue west of State Fair Park between 1945 and 1960. It is a fine example of the family groceries that supported many neighborhoods around the city. This building is typical of the commercial buildings built in the Mediterranean/Spanish style popular in the 1920s. Additional examples were built along National Avenue and Burnham and Becher Streets.

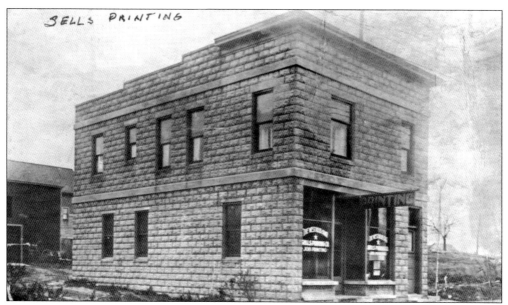

SELLS PRINTING COMPANY, 1916. Adolph F. Sells (b. 1862) came to West Allis in 1912. He founded Sells Printing Company in 1916 to publish the *West Allis Star* newspaper. Previous to the *Star*, West Allis had the *Enterprise*, *Republican*, *Independent*, and *Press*. By 1923, the *Star* was the only paper remaining in the city. In 1929, Sells sold the *West Allis Star* to his son-in-law, Lester Krebs, who published the paper until 1949. Sells Printing Company moved to a new plant in New Berlin in 1978 and today does only commercial printing. The *West Allis Star* is currently published by Community Newspapers Inc.

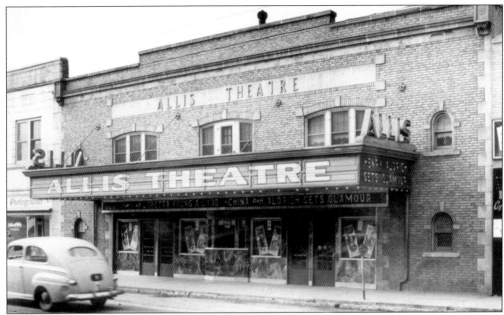

THE ALLIS THEATER, GREENFIELD AVENUE, LATE 1940S. In the 1920s, the showing of movies and presentation of plays moved from the tavern halls to the newly erected theaters of the downtown district. The Allis Theater was built in the early part of the decade, followed by the Capital Theater. Both were a very popular venue for Friday and Saturday entertainment. In 1929, a grand movie palace was built at the "Triangle" where National and Greenfield Avenues intersect. It was called the Paradise Theater. In the 1960s, the downtown theaters lost their appeal and lost business to the mall theaters built along Highway 100 on the city's western fringe.

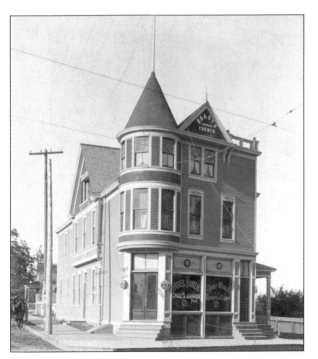

BRADY'S CORNER, C. 1900. Brady's Corner was one of the early business buildings of the east end, located at today's South Sixtieth Street at National Avenue. The building housed a small hotel and a saloon. This building, with the exception of the prohibition years, always housed a saloon. It also was home for the Veteran's of Foreign Wars Post 1912. The building site is now a small city park.

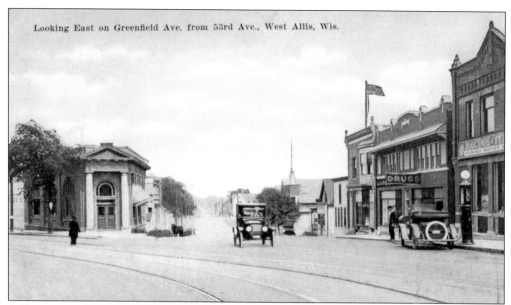

A POSTCARD VIEW OF THE "TRIANGLE," C. 1930. This was a very important business district for the east end of the city. The Triangle was also known as Old Five Points in the pioneer era. It was the home of the West Allis State Bank, the Paradise Building, and a number of small retail shops, and it was the site of the first city operated farmer's market. The neighborhood also supported a number of bakeries and meat markets of a German-Central European taste.

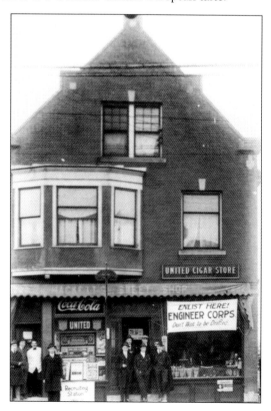

HACKETT'S SWEET SHOP, 1918. John Hackett (1864–1931) was a steady citizen of West Allis since 1908. He served on the School Board and was both an alderman and city treasurer. The sweet shop was opened in 1912 near South Seventy-first Street at Greenfield Avenue. The shop is shown here in 1918 with a window sign prompting local young men to join the Army Engineers.

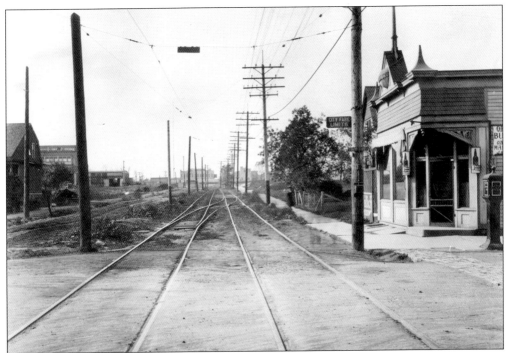

SOUTH SIXTIETH STREET AT BURNHAM, C. 1920. Heavy industry abounded in West Allis and lived side by side with small business. The tavern on the right was a local watering hole into the late 1960s. Shown here, it is one of the "Schlitz Taverns." Brewery sponsored taverns were found across Milwaukee County before Prohibition. The neighborhood around this intersection was heavily Polish and Slavic in nature with many duplex houses and ethnic shops.

RICHMOND PHARMACY, C. 1950. Richmond Pharmacy at South Sixtieth Street at Greenfield was typical of mid-20th century pharmacies. Pharmacies were usually divided into three departments: prescription counter, tobacco/news counter, and soda fountain. To most children (and adults) the soda fountain was the center of the pharmacy experience. By the 1970s, most local pharmacies had eliminated the soda fountain.

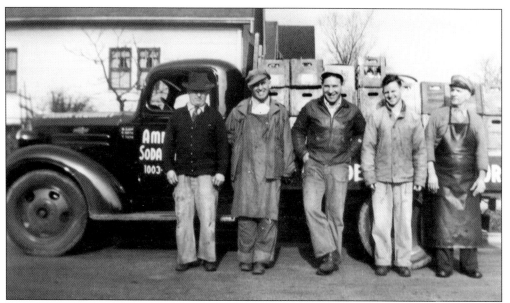

AMERICAN SODA WATER COMPANY, C. 1945. American Soda Water Company was one of two local sources for cool, sweet drinks in West Allis. The company specialized in a variety of bottled, fruit-flavored sodas that were delivered to local bars and festivals.

FREESE'S CANDY, 1980S. Since the 1930s, one of the sweetest places on Greenfield Avenue was Freese's Candy Shop. The old shop with its soda fountain was a favorite stop for theater goers on Greenfield Avenue. In 1976, Helen Freese (1902–1998), seen here with her son Richard, built a new shop a block west of the old one, specializing only in chocolates and candies. The Freese Family sold the store in 1994, but the delectable tidbits are still made on Greenfield Avenue under that well-known name.

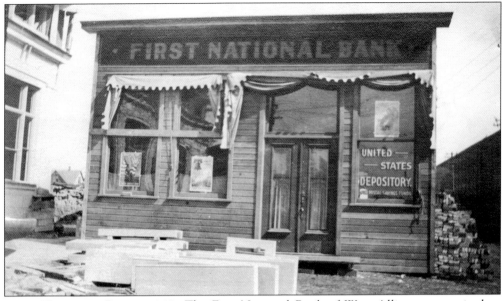

FIRST NATIONAL BANK, 1903. The First National Bank of West Allis was organized to serve the needs of the newly incorporated Village of West Allis. The bank was located on Greenfield Avenue in the heart of the new business district and growing neighborhoods around the great factories. The bank served the community well until the Great Depression when it was forced out of business.

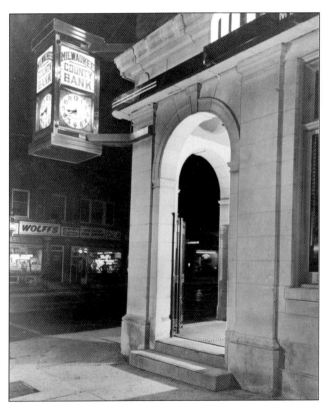

MILWAUKEE COUNTY BANK, 1965. The Milwaukee County Bank was organized in 1924 and was set up on Greenfield Avenue, as the founders believed that Greenfield Avenue had the most economic potential in the area. In 1937, the bank took possession of the failed First National Bank and moved to their location at South Seventieth Street at Greenfield. The bronze clock, seen here, was a symbol of the Greenfield Avenue business district, drawing the attention of anyone on the avenue. Milwaukee County Bank was acquired by Marshall and Ilsley Bank in Milwaukee in 1974.

Five

SCHOOLS, PARKS, AND CHURCHES

Education was of paramount concern for the pioneers. They built their first log school in 1839 along the Root River near National Avenue. The people of Honey Creek quickly built their own school and simply named it Honey Creek School, hiring William Wallace Johnson as the first teacher. The schools were also important to the community as public meeting houses and places for church services to be held. As the century wore on, a high school became a necessity and was added to the curriculum practiced at the Greenfield Fifth District School (currently the Historical Society building). After incorporation, the Village of West Allis started to expand its schools in 1905. A dedicated high school was built and four grade schools were added, Washington, McKinley, Lincoln, and Garfield, one for each ward. By 1912, West Allis added the state of Wisconsin's first adult vocational school. Since the early days West Allis has continued to offer solid, accessible education to the community. Parks were an important part of West Allis life. Many school parks were built to accommodate children in the neighborhoods of the schools. The purpose was to provide safe places to play and keep children out of trouble and to provide physical education and sports fields for organized activities. City parks popped up in each ward for the enjoyment and relation of the residents. Many county parks were instituted in the 1920s and 1930s. Greenfield Park was established in 1924, and by 1927, was recognized as the best golf park in the area. McCarty Park was organized as Eckel's Park in 1942 and was later sold to Milwaukee County and renamed McCarty Park.

Religious meetings were probably the first gatherings the pioneers attended. Many local folks provided their homes or barns for church meetings. The earliest of these was at the Cornwall House where the first Baptist mission in Wisconsin was organized in 1837. Religious houses grew as the population increased and became more ethnically diverse. Many of the major faiths represented in West Allis include Catholic, Lutheran, Episcopal, Baptist, Methodist, and Presbyterian, each having deep roots in the community. West Allis has 41 churches within the city at this time.

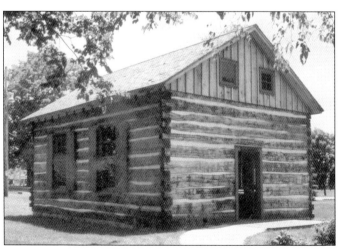

HONEY CREEK LOG SCHOOL RECONSTRUCTION, 1998. This reconstruction of the Honey Creek Log School was built as a Wisconsin Sesquicentennial project. It is a tribute to our forefathers, educators, and community spirit.

FIFTH DISTRICT SCHOOL PICNIC (OLD HONEY CREEK SCHOOL), C. 1890S. School in the good old days wasn't always about reading and writing. Here the children of all grades enjoy a picnic in the woods, probably somewhere along Honey Creek.

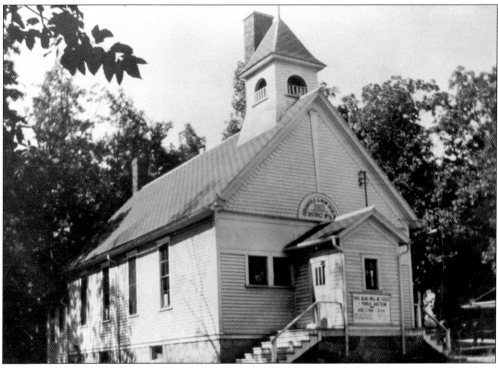

THE LAST DAYS OF COOPER SCHOOL. This was the oldest school in Greenfield Township, founded in 1839 by the Cooper family. It was sold in the 1940s to make way for a new, modern grade school known as Parkway School.

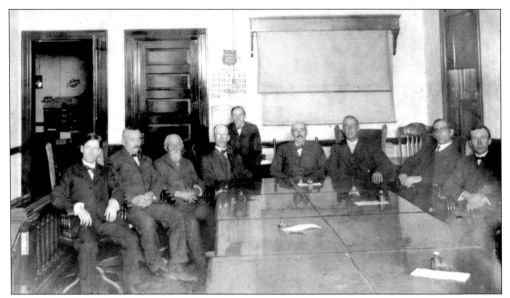

THE FIRST WEST ALLIS SCHOOL BOARD, 1906. The School Board was noticeably changed from three member rural school committees when the city was incorporated in 1906. Moving from a rural to urban school system required greater management and a larger school board. Each city ward contributed one member to the board with three members from the city at large, all appointed by the mayor. The board met in the City Hall meeting room above the fire department.

MCKINLEY SCHOOL, C. 1925. McKinley School was one of the first schools established after village incorporation in 1902. Originally a two room wood structure, the school was continuously improved through the 1920s and 1930s. Here, as was usual in the early years of the 20th century, children assemble before the flag before entering the school.

SCHOOL BUS AT MCKINLEY SCHOOL, C. 1930. West Allis schools were leaders in recognizing the needs of special students in the schools. In the mid-1920s McKinley School was designated the "orthopedic school" for children with disabilities. Here they received therapy, skilled nursing, as well as a solid education.

SCHOOL PLAY, WASHINGTON SCHOOL, C. 1925. Washington School was in the city's first ward at South Sixty-second at Lapham. It began as a two-room frame school and slowly grew into a 25-room brick school by 1925. This was one of the fastest growing schools in the city due to the increase in immigrant (Polish and Slavic) families in that ward, which may account for the variety of costumes and people represented by these young thespians. An addition in the late 1930s allowed for the establishment of Horace Mann Junior High School on the same school block.

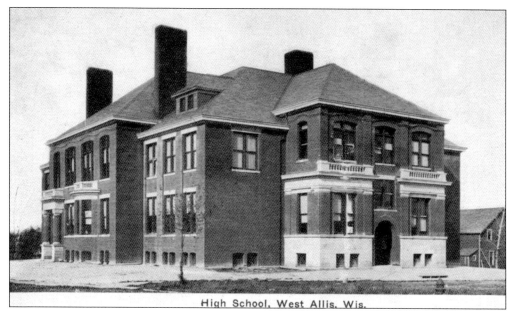

WEST ALLIS HIGH SCHOOL, 1910. This school was built in 1907 and accredited as a high school in 1908. The school grounds were shared with Lincoln Elementary School. By World War I it was apparent that the high school was outgrown. Construction on a new building began in 1919. This building became the first junior high school in 1920 and was replaced in the 1930s by a new all brick junior high school named for educator John Dewey.

WEST ALLIS HIGH SCHOOL FOOTBALL TEAM, 1909. Sports were an initial part of the school curriculum as was home economics, industrial arts, and music.

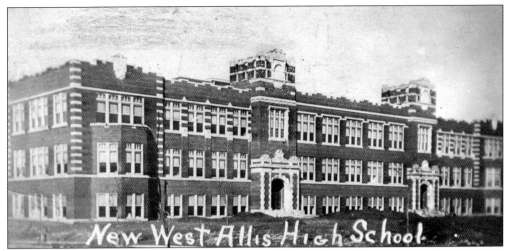

WEST ALLIS HIGH SCHOOL, 1921. All new for 1921! This building occupied an entire city block at South Seventy-sixth Street and National Avenue. Amenities included a swimming pool and gymnasium. Later a sports field, Warne Field, was added directly across the street. This was the city's only high school until Nathan Hale Junior High was elevated to high school status in 1942. Then the high school became known as West Allis Central High School. Both city schools were joined by West Milwaukee High School when the West Allis School system merged with the West Milwaukee School system in 1959. The "Old Central," as it was known in the 1970s, was closed, and all students were shifted to a newly converted building, oddly, the old Nathan Hale High School on Lincoln Avenue at South Eighty-sixth Street, in 1974.

WEST ALLIS CENTRAL VS. NATHAN HALE, FALL 1974. Here is the classic cross-town rivalry, both city high schools fighting for bragging rights for the whole next year.

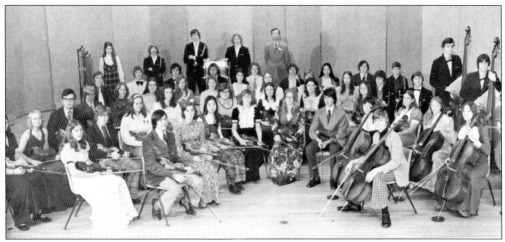

WEST ALLIS CENTRAL HIGH ORCHESTRA, 1975. Music has been part of the West Allis school curriculum since 1906. Sixty-nine years later it is still a vibrant part of school life. Most of these young people had been playing their instruments since third grade when school lessons began for children. In addition to the orchestra, each high school had a marching band/symphonic band, pep band, and a variety of choral groups.

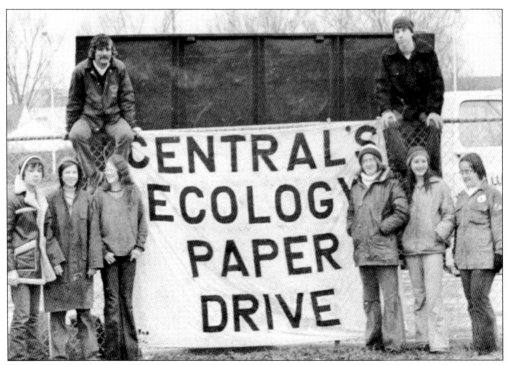

WEST ALLIS CENTRAL ECOLOGY CLUB, 1975. The students of West Allis are brought up with ideals of community service throughout their school careers. Central High students show their concern and enthusiasm for new community values instilled by the Earth Day celebrations that began in 1970.

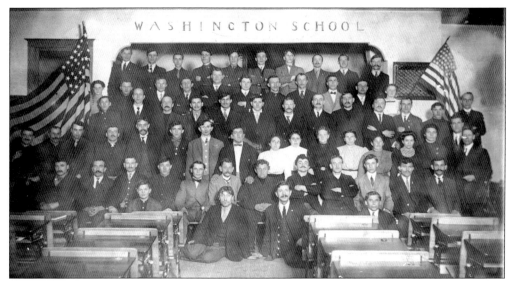

AN EARLY ENGLISH CLASS FOR IMMIGRANTS, WASHINGTON SCHOOL, C. 1915. The School Board organized night schools for adults in 1910. Lincoln and Washington Schools were the sites selected for the classes because of their proximity to the factories of West Allis. Classes were taught in English to improve immigrant worker's language skill and comprehension of technical materials. Classes were also taught in cooking, dressmaking, shop, math, and electricity.

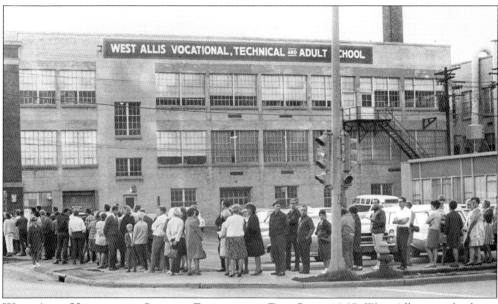

WEST ALLIS VOCATIONAL SCHOOL, ENROLLMENT DAY, LATE 1967. West Allis was a leader in vocational education in Wisconsin. In 1911, the school board authorized a board of vocational education to establish a curriculum of continuing education for adults. The first vocational school was the old McKinley School, moved to a site near Seventieth Street at Madison. As this was a small building, vocational classes were also offered in the ward schools. In 1927, a fine masonry structure was opened on South Seventieth Street, across from Allis Chalmers Company. The school was operated by the city of West Allis until the early 1970s, when a great consolidation of county-wide services created the Milwaukee Area Technical College.

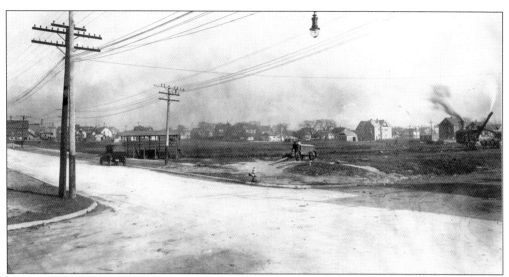

CONSTRUCTION OF WASHINGTON SCHOOL PARK, 1922. With the construction of additional schools after World War I, the city enlarged the parks that were built in proximity to most grade schools in the area. The purpose was to give children a safe place to play and take physical education class. The parks were smartly landscaped to provide the community near each park with a green space in which to relax. Beginning in 1916, the school board opened the parks to "summer playgrounds" with organized activities for children. Today this park is known as Liberty Heights Park at South Sixty-second Street at Lapham.

KOPPERUD PARK, C. 1935. In 1926, there was a public call for a new park on the north end of the city. On South Seventy-sixth Street and Pierce Street was a large lot that contained the city's number one septic tank. As the city was on the verge of gaining septic sewer access a call went up to remove the tank and create a park. The park was completed in 1929 with the opening ceremony attended by a huge crowd. In the 1970s, Federal Malleable Iron Company attempted to buy the park for factory expansion but was turned down. West Allis has less than 10 city parks.

MCCARTY PARK, 1961. Originally this park was the Eckel's Farm. The City purchased the land in 1942 for a park, but immediately sold it to Milwaukee County for $1. During World War II, people in the area were allowed to plant Victory Gardens in the park. After the War, the park was used for temporary veterans' housing, with rows of Quonset huts housing veterans' families. The huts were removed when the veteran's housing units at South Seventy-second Street and Beloit Road were occupied. McCarty Park lagoon was built as a flood control measure for Honey Creek and the pool was a stipulated feature when the City transferred the land to the county. The park is a popular urban attraction for baseball enthusiasts all summer long. The park is named for William E. McCarty, a Milwaukee County Board supervisor from 1908 to 1920.

GREENFIELD PARK, 1970. The park was previously the Sebastian Bradly farm where fine crops of hops were raised for the local breweries. The farm was sold to Milwaukee County for a park after the old farmer's death. The name "Greenfield Park" comes from the park's location in Greenfield Township, not from Greenfield Avenue. By 1927, the golf course was said to be the finest in the area. The rest of the park was open land used for picnicking and hiking. A lagoon and fine pavilion were built in the park by the WPA in the 1930s. In 1954 the park was part of the lands annexed by West Allis and thus became part of the city. Greenfield Park is also home to the largest registered Pinchleaf Willow in the area.

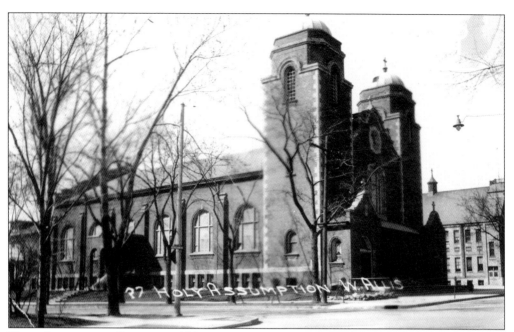

HOLY ASSUMPTION PARISH, C. 1920.

HOLY ASSUMPTION CONGREGATION. Holy Assumption Parish was established in 1901 and grew right along with the Village of West Allis. The church cornerstone was laid in 1902 with Father Julius Hubert Burbach as the spiritual leader of the 13 family congregation. The School Sisters of Notre Dame came to open a school that year. The new church/school was opened in August 1902. By 1916, the congregation had outgrown the old church, and a new one was being built. It took until 1925 to finish the new structure, a handsome Spanish Mission style building on the corner of South Seventy-first Street at Orchard. By the time the second church was built, the congregation numbered in the hundreds. A few of the families are shown here.

MONSIGNOR JULIUS HUBERT BURBACH (1874–1947). Father Burbach was a native son of West Allis. Community service was his greatest hallmark as a priest and citizen. He was responsible for building one of the most prominent churches in Milwaukee County. He served on a number of civic commissions and wrote the first two histories of the Village, and later the City of West Allis.

ST. MARY'S HELP OF CHRISTIANS CHURCH, C. 1910.

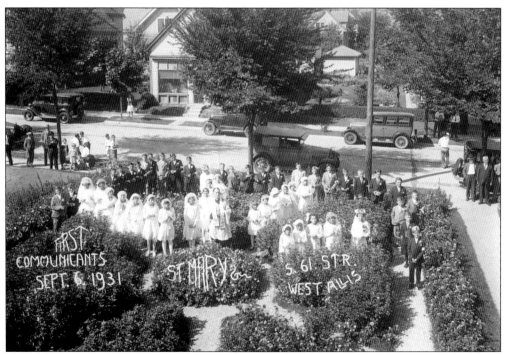

ST. MARY'S COMMUNION CLASS, 1931. St. Mary's Church was established in West Allis in 1908 for the growing Slovenian community on the city's east end. The church was built on South Sixty-first Street near Madison. In 1948, a school was added to the parish. A new church was built and dedicated in 1968. This church was the heart of the Slovenian community for many years. Children were very important in the community and were raised in the faith and taught the ways of Slovenian culture.

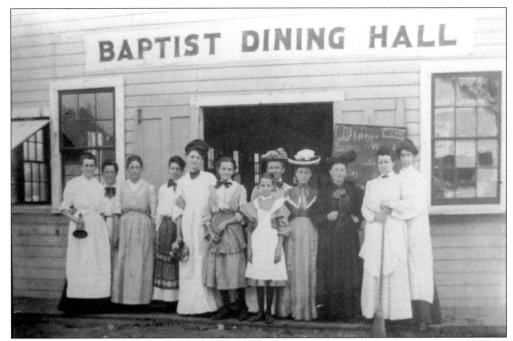

BAPTIST DINING HALL, STATE FAIR PARK, C. 1905. Many local churches ran dining halls at State Fair Park. At the hall one could get a good meal and helping of scripture. The Methodist Dining Hall burnt down in 1914 and was immediately rebuilt, but the days were numbered and the church halls disappeared from the Fair Park by the 1930s.

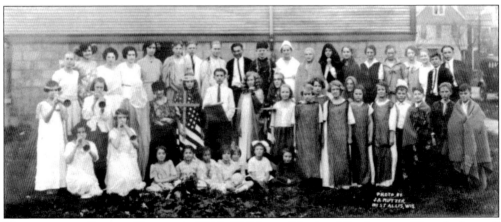

MEMBERS OF A CHURCH PAGEANT, 1926. Children of the local Presbyterian Church show off their costumes for the church pageant, probably for the Christmas celebration.

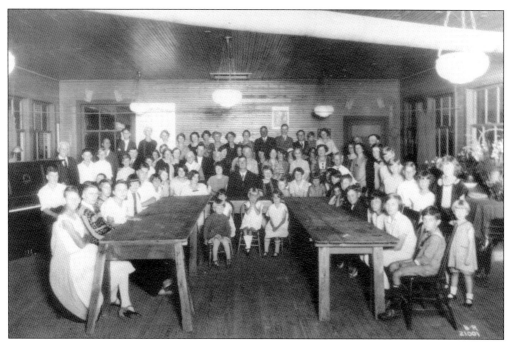

WOODLAWN COMMUNITY BAPTIST CHURCH, C. 1925. West Allis had a number of Baptist Churches in the city. Woodlawn was situated at the western border of the city near Woodlawn Avenue (South Ninety-second Street). The church operated until 1938 and shows a name change to Christian & Missionary Alliance Church in 1940.

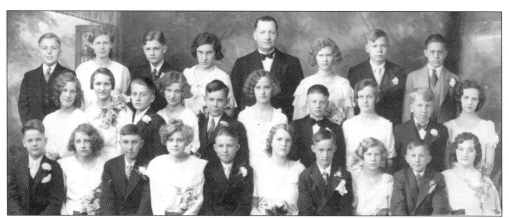

CONFIRMATION CLASS, JORDAN LUTHERAN CHURCH, C. 1931. Jordan Evangelical Lutheran Church was a German Lutheran church established in 1894. In 1928, the church began the first Christian day school in the area. It became an independent Lutheran church in 1910. The current church is in the 1600 block of South Seventy-seventh Street. In 1985, the church bought the old Johnson School (South Eighty-fourth and Beloit Road) from the City of West Allis as the new home for their school.

MOUNT HOPE EVANGELICAL LUTHERAN CHURCH, PROCESSION, C. 1957. Mount Hope was established in West Allis in 1925. The first church was a frame building at South Sixty-ninth at Lincoln Avenue. The church seen today was built in 1949 at South Eighty-sixth and Becher Streets. The church is well-known for its active commitment to Lutheran ministry and youth programs.

MARY QUEEN OF HEAVEN CHURCH FESTIVAL, 2003. Mary Queen of Heaven Church was established in West Allis in 1968 to serve the Catholic community on the city's far west end. Church festivals are a traditional summer treat and are presented by most Catholic churches in the area. Festivals serve as fund raising opportunities and as a way to establish ties to the greater community.

Six

MEET ME AT THE FAIRGROUNDS

The George Stevens farm was positioned on the north side of Greenfield Avenue, just inside the Wauwatosa Township line. In 1891, the Wisconsin Agricultural Society, led by North Greenfielder Tom Fleming, bought the Stevens farm and built the permanent home of the Wisconsin State Fair. Camp Harvey was built on the Fairgrounds as a staging ground for Wisconsin forces destined to fight in the Spanish-American War (1898). Since that time the Fair has continued to grow and improve. Last year a new grandstand was built, and the year before a new exposition hall was built. There is always continuous improvement in the livestock and agricultural areas. The Fair attracts people from all over the region, and international visitors are common. It is truly Wisconsin's party.

The Fair Park was also instrumental in the development of aviation in Wisconsin. The first demonstrations of manned flight took place at the Fair. Aircraft even raced automobiles in the days before World War I. The Fair Grounds claims itself as the birthplace of Wisconsin aviation, as a flight school and airfield were established near the north end of the park in 1912. A number of West Allisans enthusiastically embraced flying, building, and flying planes in the area. Most interestingly, West Allis and the Fairgrounds were the place in which Alfred Lawson assembled the first commercial airliner in America.

And finally, the Fair Grounds are a place where Olympic heroes are trained. West Allis has, since the 1930s, been a place where ice skating is taken very seriously. Many skating champions got their start on the School Park ice rinks. Skills were honed on the Olympic Ice Rink, and its successor, the Pettit Ice Center, is an international Olympic training facility as well as a community skating rink.

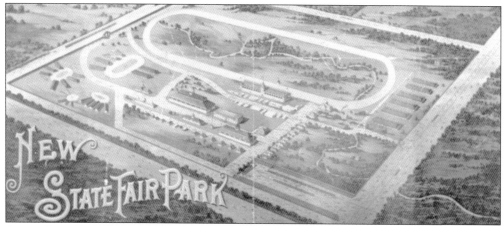

STATE FAIR POSTER, 1892. A bird's eye view of the new Fairgrounds clearly shows the stream, race track (oriented north-south), and exposition buildings, as well as rail access to the park via the Chicago and Northwestern and Chicago (south entrance), Milwaukee and St. Paul railroads (north entrance).

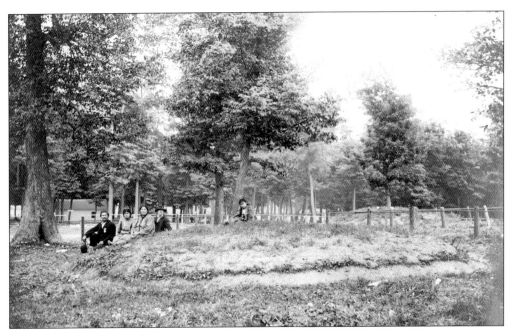

ANCIENT INDIAN MOUNDS, C. 1900. Seen here are two of the ancient Indian mounds at State Fair Park. These mounds were located very near Honey Creek near modern South Eighty-fourth Street at Greenfield Avenue. These mounds were built by Woodlands People between 100AD to 1000. A mere 50 years before this photo there were a number of mounds at this site, then there were two and are now inside the grounds of the Department of Natural Resources pavilion. (Photo courtesy of the Milwaukee Public Museum.)

OJIBWA ENCAMPMENT, C. 1900. Encampments of Wisconsin Native Americans were a usual part of the State Fair in the late 19th and early 20th centuries. Members of the encampment would demonstrate traditional crafts and games of lacrosse. Note the three distinct styles of shelter in the photograph, the longhouse, the wigwam, and the bark teepee. (Photo courtesy of the Milwaukee Public Museum.)

FAMILY PORTRAIT FROM THE 1909 STATE FAIR. The Fair was a showplace for agriculture, business, and plain old fun—something for everyone. Visiting the Wisconsin State Fair is as much a tradition now as it was for this happy West Allis family in 1909.

CATTLE AND NEW LIVESTOCK BARN, C. 1910. The livestock exhibition building was built in 1905 and was the pride of the Fair. Exhibitors from all over the Midwest showed their best animals here. The Rust and Cooper families of West Allis showed their cattle here, winning many prizes and breeding awards that helped make their farms internationally important sources of dairy cattle. This year, 2003, a new double-deck livestock barn was opened.

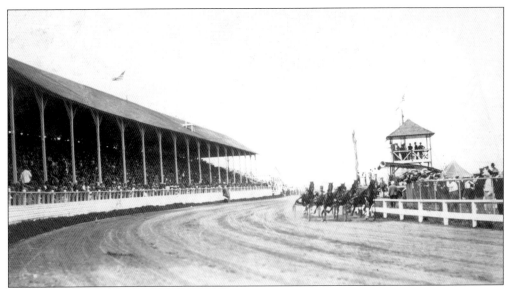

HARNESS RACE, 1920. Harness racing and raising trotting horses was a past-time and business for a number of Milwaukee County gentleman farmers, among them George Stevens, John L. Mitchell, and Sebastian Bradly. It was natural that the State Fairground would host harness racing. At the time of this photo, horse racing and auto racing shared the same track. Grounds men alternately softened the track for horses and compacted the track for automobiles. Horseracing lost favor after World War II and was wholly replaced by midget car, stock car, and Indy car races.

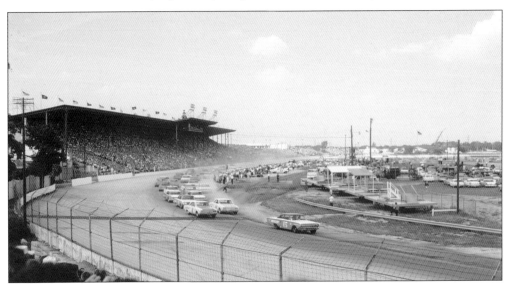

STOCK CAR RACE, C. 1967. Auto racing has been held on the Fairgrounds since 1903. Often the races were part of the Fair itself. Some exhibitions pitted automobile against aircraft, both blimps and airplanes. In later years the race track was used independently of the State Fair with a number of races held over the summer months. Bicycles, motorcycles, midget cars, stock cars, and Indy cars raced at the Milwaukee Mile over the years. The Rex Mays Classic Indy Car race began at the track in 1950. There were even snowmobile races held at the track in 1973. The old dirt track was first paved in 1954, with smaller dirt tracks on the infield. (Photo courtesy of the Wisconsin State Fair Archives.)

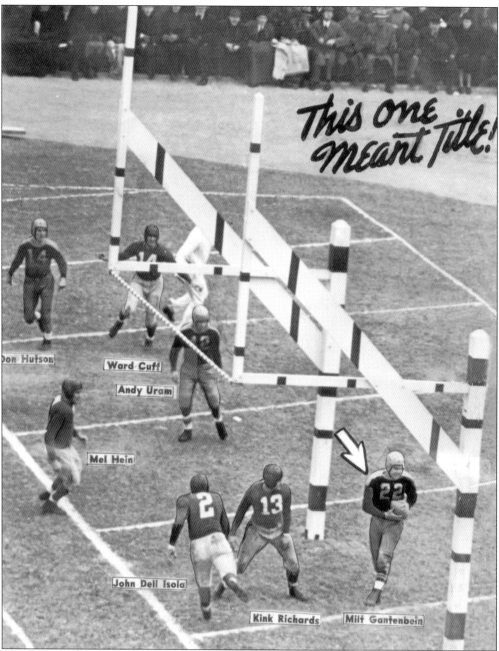

WEST ALLIS WAS "TITLETOWN" IN DECEMBER 1939. The Green Bay Packers played the New York Giants in the Seventh National Football League Championship game before a packed grandstand of 32,000 people. The football field was laid out inside the quarter-mile dirt track. It was a cold day with stiff 35 mile-per-hour winds, and the Packers easily defeated the Giants by a score of 27 to 0. The Packers played in West Allis at the Fairgrounds from 1935 to 1939. (Photo courtesy of Journal Sentinel Inc.)

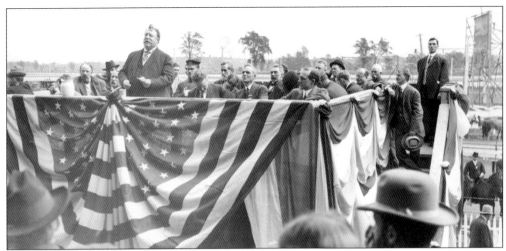

PRESIDENT WILLIAM HOWARD TAFT AT STATE FAIR, 1909. Presidents and politicians are always at the State Fair. Abe Lincoln made a campaign speech at the 1859 State Fair when it was held at the Cold Spring Grounds in Milwaukee. President Taft visited the Fair in a grand motorcade up Greenfield Avenue. He spoke to the Grandstand crowd and judged some cattle. The Fair has always been a place for politicians to press the flesh. In recent memory, Senator William Proxmire could be met outside the Horticulture Building, and no one can attend the Fair without having a cold glass of milk courtesy of Senator Herb Kohl. (Photo courtesy of the Milwaukee Public Museum.)

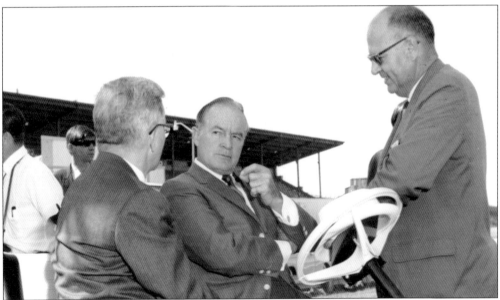

BOB HOPE (1903–2003) AT STATE FAIR, 1966. It was common for "big name" stars and acts to work the Fair. Much of the fascination of the Fair rested in the agricultural demonstrations, technical demonstrations, the races, the occasional circus, and the midway. Certainly by the 1950s, nationally known music and comedy acts were a regular part of the entertainment. Bob Hope was a regular visitor to Milwaukee, making many stops here during the bond drives of World War II. In 1966, he shared the grandstand with Perry Como. Bob Hope would again visit the Fair in 1980 along with the Beach Boys and Alice Cooper.

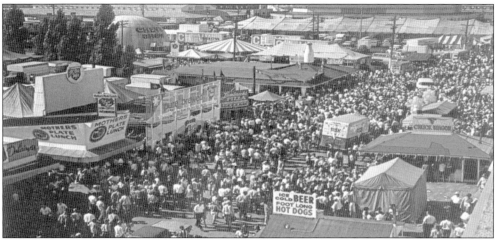

RESTAURANTS AND FOOD VENDORS AWASH IN HUNGRY FAIR-GOERS, 1975. The Fair has always been a home to local restaurants, venders, and charities who prepare all of those special treats that taste best at the Fair. West Allis churches had dining halls at the Fair in the early days. Many ethnic restaurants and specialty food stores have booths at the fair. And who could forget the ever-present cream puff, sold at the Fair by the Wisconsin Baker's Association since 1924. (Photo courtesy of the Wisconsin State Fair Archives.)

BARNYARD PUNS BILLBOARDS, 1980 TO 1990. These billboards were all over the state, touting the fun side of the State Fair. No one could ever forget the "Days of Swine and Roses." Other clever ads in the series included "Check Out the Chicks" and "Here's Looking at Ewe Kid." This advertising campaign won national attention for the Fair. (Photo courtesy of the Wisconsin State Fair Archives.)

WORLD CHAMPION INDOOR SPEED SKATER ALLEN PETRIE, 1934. Allen Petrie won a number of medals in short track and sprint skating. Young men like him set the stage for the establishment of the West Allis Skating Club in 1935. The Club was operated under the direction of the recreation department. By 1949, the club won so many honors that West Allis was called the "Skating Capital of Wisconsin." Over the years the club has produced the finest skaters in the state.

GREAT LAKES SPEED SKATING CHAMPIONSHIP, WILSON PARK (MILWAUKEE), 1979. The West Allis Skate Club hosted this event each year. This particular year the club established the Ernest Dorrow Championship Team Trophy to honor past recreation director, Ernest Dorrow Sr., who led the West Allis Recreation Department and supported skating programs for 44 years. The program also mentions two young people who raced in 300 meter events in the "midget" category, Dan Jansen of West Allis and Bonnie Blair from Illinois. Dan Jansen went on to win the men's speed skating gold medal in the 1994 Winter Olympic Games in Lillehammer, Norway.

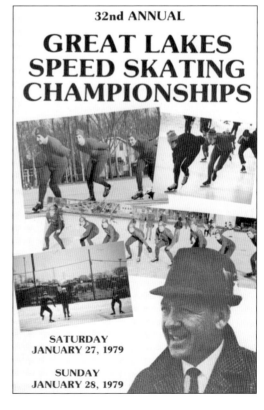

THE PETTIT NATIONAL ICE CENTER, 2003. Since the late 1950s, State Fair Park has been central to the development of the skating sports and entertainment in West Allis and all of Wisconsin. Holiday on Ice was founded at the Fair Ground ice rink in 1945. In 1959, the coliseum at the Fair Park became the home of the Milwaukee Falcons, a semi-pro hockey team. This move prompted the construction of a permanent ice rink for team and community use. A figure skating school was operated by national gold medalist Patsy Halverson at the site. In 1966, a new ice rink opened at the Fairgrounds, the Wisconsin Olympic Ice Rink, and served the community until replaced by the Pettit National Ice Center in 1992. The Pettit Center is an Olympic training facility that regularly hosts national and international skaters and events and provides community skating opportunities.

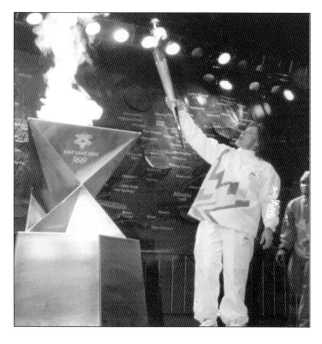

THE OLYMPIC TORCH RELAY. Olympian Bonnie Blair accepts the Olympic flame during the Olympic torch relay through Milwaukee and West Allis. The Olympic flame was relayed from state to state on the way to the 2002 Winter Games in Salt Lake City, Utah. Bonnie Blair skated in West Allis in her youth and trained at the Pettit Center for her 1994 Olympic meets. (Photo courtesy of the Pettit National Ice Center.)

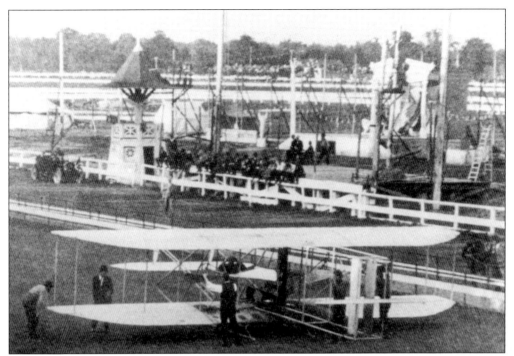

FIRST MANNED AIRCRAFT FLIGHT IN WISCONSIN, 1910. In September 1910, the Wright Airplane Company came to the Wisconsin State Fair to show off one of their new Model B aircrafts. Aviator Arch Hoxey made the flight.

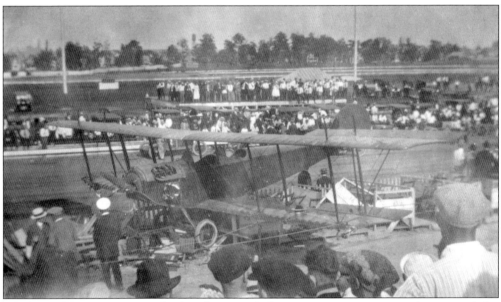

A HARD LANDING, C. 1925. Air shows and demonstrations were a regular part of the entertainment and flew over the race track at State Fair Park. On landing, this airplane took a bad hop and came to rest on top of a number of spectators. Note the mass of folding chairs under the plane. The West Allis police ambulance was on standby, as usual, and carted the shaken spectators to a nearby hospital. That old Nash Ambulance certainly was handy that day.

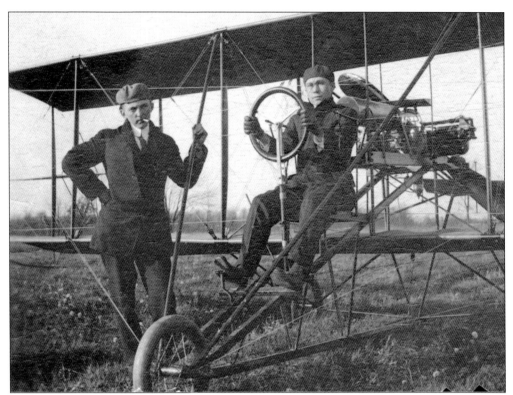

Two Guys From West Allis Built a Plane, 1911.

Plane and Hanger at Airfield Near South Sixtieth Street at Lincoln, 1911.
West Allis was on the cutting edge of amateur aviation in the Milwaukee area. Stephen Nagalski built a plane and hanger at South Sixtieth Street at Lincoln (the site of St. Rita's Catholic Church). He and John Kaminski of Milwaukee took the plane up for regular flights over the city. The plane and hanger were destroyed in a tornado that hit the area in 1914. From 1910 to 1917, a number of West Allis men were involved in building and flying planes, many from the 40-acre aerodrome at the north end of State Fair Park. West Allis and part of Greenfield Township were considered as a site for the main county airport, but that honor fell to Oak Creek Township in 1926.

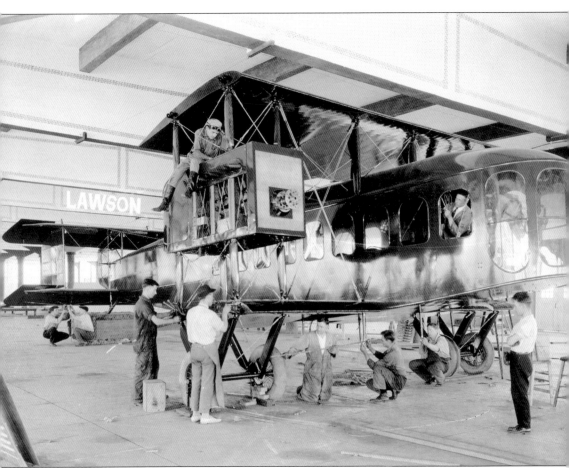

THE LAWSON C-2 AIRLINER UNDER CONSTRUCTION, JULY 1919. After World War I, Alfred Lawson (1869–1954) proposed a fleet of large passenger airliners flying from hub to hub across America. Lawson, owner of an aircraft manufacturing plant in Green Bay, came to Milwaukee and proposed his plan to Milwaukee city fathers. He manufactured the parts in Milwaukee and brought them to State Fair Park in West Allis, where he assembled the great machine in the Automobile Exhibit Hall near South Eighty-fourth Street at Greenfield. The maiden flight from Milwaukee to New York, Washington DC and back was hailed as a 2,000-mile success, but the airplane was never a commercial success. Lawson left the aircraft business in 1928 to pursue an academic life. (Photo courtesy of the University of Wisconsin-Milwaukee Archives, Golda Meir Library.)

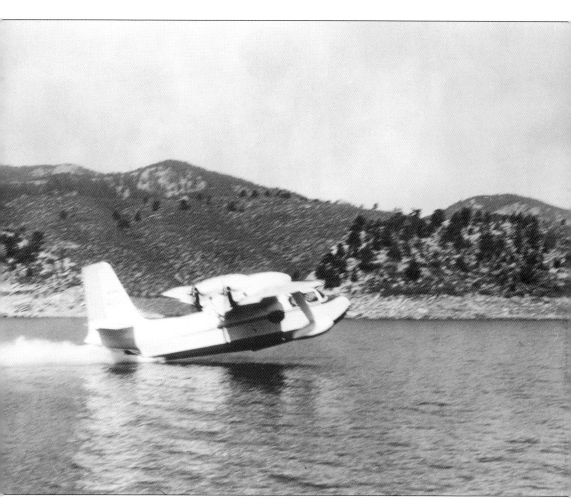

THE ROYAL GULL SEAPLANE, 1954. In 1953, Francis Trecker (president of Kearney & Trecker Company in the 1950s) spotted this plane while on a trip to Italy. Trecker was an enthusiastic aviator and decided that Kearney & Trecker Company would import, assemble, and market the plane in the United States and Canada. The West Allis plant was the hub of manufacturing for the aircraft. The pusher type, gull-winged seaplane cost $75,000 in 1954.

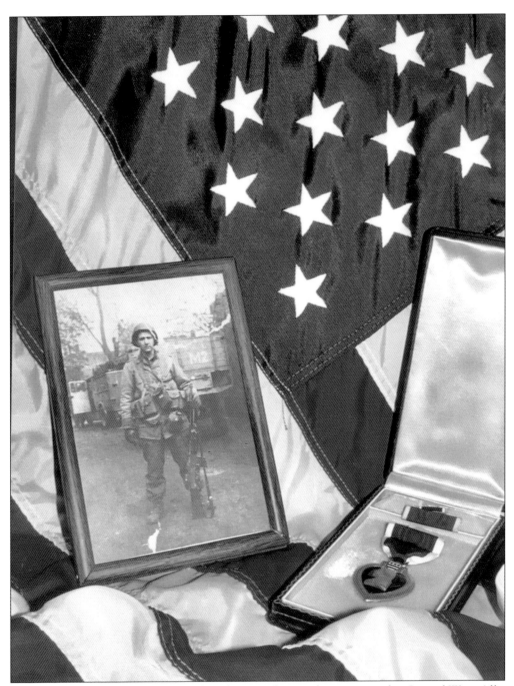

TRIBUTE TO A VETERAN, 2003. This photograph won first prize in the City of West Allis Fourth of July photo contest. The photo is a tribute to a West Allis soldier by his daughter and stands for all the men and women of West Allis who gave their youth, and the few who gave their lives, in defense of the United States, from the Civil War to the Iraqi War. The soldier in the photo is Howard J. Bradshaw, who served in the 83rd Division, 329th Regiment, Infantry, in Europe during World Ward II. He was awarded the Purple Heart for wounds received during the Elbe River crossing, April 1945. (Photo courtesy of Barbara Hart.)

Seven
REMEMBRANCE AND CELEBRATION

West Allis is a city that respects the commitment and deeds of its citizens and takes the time to recognize the accomplishments and joys of civic life. West Allisans honor the veterans and civic leaders who have made a difference in the city's life. Since the Mexican-American War, West Allis men and women have served their country proudly. On major holidays, in Honey Creek Cemetery, the headstones of veterans are still adorned with American flags. In the recent past, Veteran's Park was rededicated to include a central memorial and memory walk proclaiming the names of those who served this country.

West Allis remembers those who served the city. A tradition of grass-root involvement in civic projects and the political process is a hallmark of city life. City officials, citizen boards and committees, business groups, and fraternal organizations like the Kiwanis, Rotary, Lions, and Masons, and the over-arching West Allis Charities have distinguished histories of community support, good works, and philanthropy. Celebrations of community remember the earliest residents, pioneers, and immigrants. The West Allis Historical Society and the Historical Commission carry the memories of West Allis and secures the future of the city's history. Outwardly demonstrated through the impressive line-up of parades and civic events, West Allisans relish and celebrate community will, perseverance and independence in building and maintaining the principals and progress of the community.

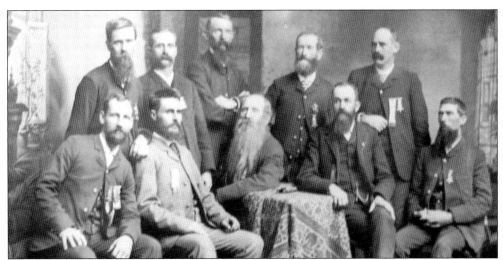

GRAND ARMY OF THE REPUBLIC REUNION, 1886. The Grand Army of the Republic (GAR) was formed in 1866 as a veterans' group for those who served in the Union forces. In 1886, the Grand Encampment was held in Milwaukee, where this reunion photograph of Company I, 65th Illinois Regiment was taken. Myron Strong, son of West Allis pioneer Rueben Strong, is seated, second from the left. The last GAR encampment was held in Indianapolis in 1949 with six Union veterans in attendance.

FREDERICK K. BARNEKOW, LATE 1880S. Frederick Barnekow (b. 1826) was a German immigrant who came to America just before the Civil War. He served in the King's Army in Germany. As a new citizen, he served in the Union forces, 24th Wisconsin Volunteers, from 1862 through 1863 when he was captured by Confederate forces. This photo, probably taken at the 1886 GAR Encampment, demonstrates his patriotic pride, but it also shows off his old German Army coat and his GAR medal (the inverted five-pointed star). Barnekow operated a farm near South 100th Street near Schlinger Avenue. Barnekow Road was named for him. (Photo courtesy of Barbara Hart.)

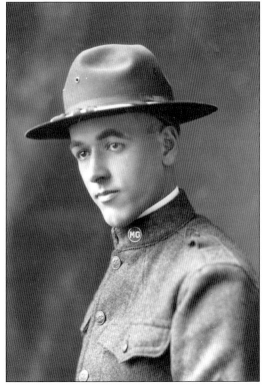

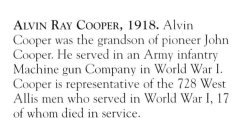

ALVIN RAY COOPER, 1918. Alvin Cooper was the grandson of pioneer John Cooper. He served in an Army infantry Machine gun Company in World War I. Cooper is representative of the 728 West Allis men who served in World War I, 17 of whom died in service.

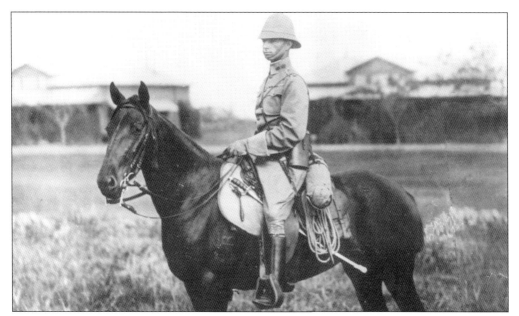

LIEUTENANT WILLIAM MITCHELL, US ARMY, PHILIPPINES, 1900. William "Billy" Mitchell grew up on the family farm, Meadowmere, in Greenfield Township. At Meadowmere he learned to hunt and fish and was exposed to the many diplomats, artists, politicians, and soldiers who visited his father, Senator John Mitchell. Billy was instilled with the values of service and love of country. At age 19, he enlisted for service in the Spanish American War. He was quickly promoted and sent to serve in the Philippine Insurrection (1899-1901). (Photo courtesy of the Milwaukee County Historical Society.)

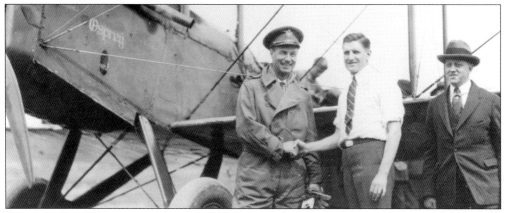

GENERAL BILLY MITCHELL AT THE MILWAUKEE COUNTY AIRPORT, 1922. Billy Mitchell served with distinction during World War I. Rising to the level of colonel, he was the first chief of the Army Air Service. He led the first US air raid on German positions (Battle of St. Mihiel) and was promoted to the rank of general. In 1919, he became the Director of Military Aeronautics, advocating a strong aircraft industry and military air service. Mitchell is famous for his demonstration of strategic bombing in 1921 and his outspoken criticism of government neglect of national defense. He underwent a court martial for his position and resigned from the Army in 1926. He vigorously worked for American air power until his death in 1936. Billy Mitchell is buried in the family plot at Milwaukee's Forest Home Cemetery, a short distance from his childhood home. (Photo courtesy of the Milwaukee County Historical Society.)

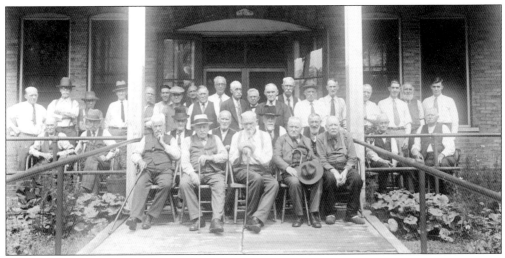

OLD VETERANS OF SOLDIERS' HOME, C. 1910. The National Soldiers' Home (now the Zablocki Veteran's Center and Hospital) was established in Milwaukee County directly after the Civil War. It was a rest home, hospital, and center for the administration of veteran affairs. Elderly and infirmed soldiers were housed in dormitories organized in military-like companies. The National Home abuts the eastern border of West Allis with the old Mukwanago Road, now National Avenue, skirting the south side of the Federal Reserve. Over the years, the soldiers of the National Home were provided with clothing, food, and books by charitable organizations from West Allis and the company of many West Allisans who never forgot their sacrifices.

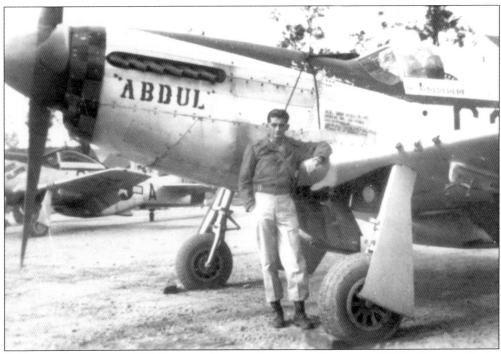

CLAYTON GIMLER AND P51 FIGHTER PLANE, EUROPEAN THEATER, 1944. Clayton Gimler poses with a P51 Mustang fighter plane, one of the most numerous, heavily armed, and successful aircraft in US military history.

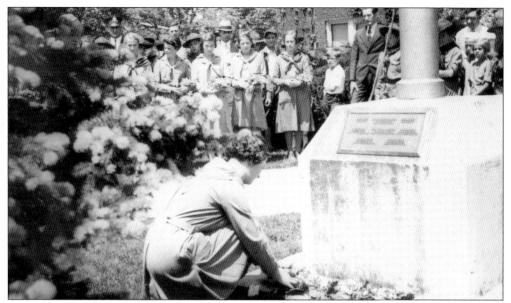

MEMORIAL DAY CEREMONY, 1932. This community Memorial Day ceremony took place at the West Allis High School. The Boy Scout and Girl Scout troops laid wreaths at the base of the school flagpole where a small memorial plaque remembered the honored servicemen of West Allis.

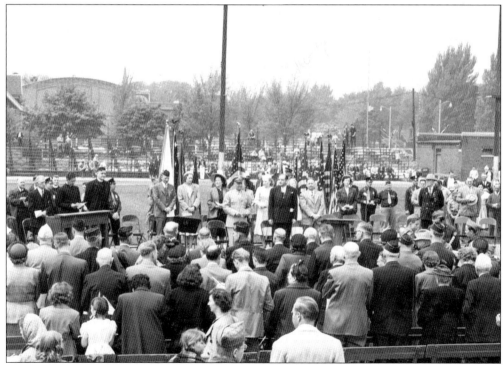

MEMORIAL DAY CEREMONY, WARNE FIELD, 1950. The West Allis High football stadium at Warne Field hosted this Memorial Day ceremony in 1950. West Allisans crowded the bleachers to hear US Senator Joe McCarthy address the crowd.

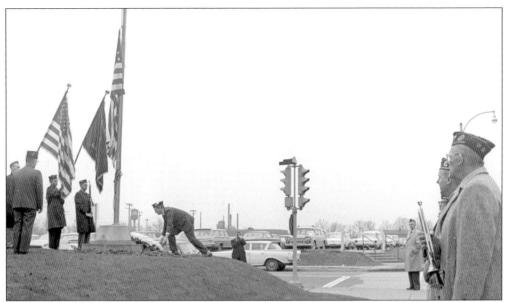

ARMISTICE DAY, 1965. Here members of the Allis Chalmers American Legion Post place a wreath and prepare to play taps at 11 a.m. on the 11th day of the 11th month of the year. This was the traditional moment of National recall and remembrance since the signing of the armistice ending World War I on November 11, 1918. This scene took place outside the Allis Chalmers Clubhouse on the corner of South Seventieth Street at Washington Street.

VETERANS MEMORIAL, VETERANS PARK, 1993. In November of 1960, Central Park, at South Seventieth Street at National Avenue, was renamed Veterans Park to honor West Allis servicemen. The fine granite monument in this photo was dedicated on Memorial Day 1993 under Mayor John Turck. On Veteran's Day 1998, a Walk of Honor was added to the monument and dedicated under Mayor Jeannette Bell.

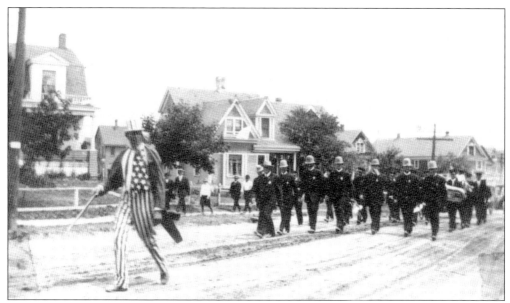

FOURTH OF JULY PARADE, 1913. Local grain merchant, Jerry DeGroot, puts his best foot forward as a very tall Uncle Sam for the Fourth of July festivities and parade along National Avenue. The parade included patriotic floats sponsored by the Women's Club and local businesses. The Fourth of July Parade is a West Allis tradition and is presented yearly. Today the parade leads the community up Greenfield Avenue to City sponsored festivities, entertainment, and a grand fireworks display at Wisconsin State Fair Park.

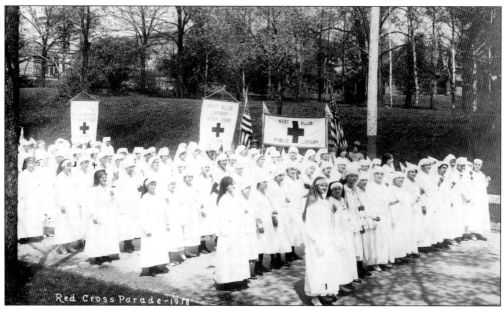

WEST ALLIS PUBLIC LIBRARY RED CROSS VOLUNTEERS, 1918. Many organizations and businesses organized Red Cross Volunteer groups to roll bandages and prepare comfort kits for American soldiers serving "Over There" in France. Here the volunteers of the West Allis Public Library form ranks for a photo at State Fair Park. The banners and formation were in preparation for a grand "Red Cross" parade in downtown Milwaukee.

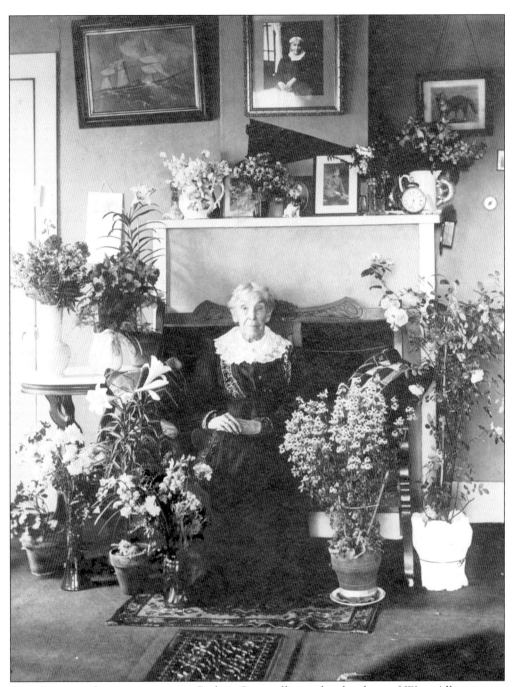

MISS BASHUA CORNWALL, 1920. Bashua Cornwall was the daughter of West Allis pioneer Eber Cornwall. This photograph was taken on the occasion of her 100th birthday in 1920. Miss Cornwall was known as a suffragette and supporter of the temperance movement. She was also a staunch supporter of the local Baptist church and is recognized as a founding member of Wisconsin's first Baptist church, established in her father's home in 1836. Miss Cornwall is also believed to be the oldest suffragette in Wisconsin to cast her vote at age 100. Bashua Cornwall died in 1923 and is buried in the Wauwatosa Cemetery.

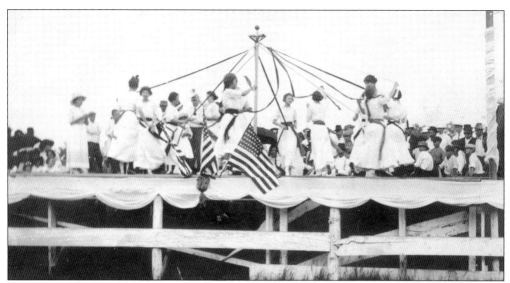

MAYPOLE DANCE, 1917. Ladies of the Women's Club demonstrate ethnic dance at the 1917 Fourth of July festivities at State Fair Park. This celebration of dance demonstrates an attachment to immigrant roots while displaying the vigor of American patriotism. At one time there were three amusement parks and the Modernistic Ballroom on the grounds. And in the early years there was also a rambling stream and groves of trees for picnicking. West Allisans used the park for their major celebrations like All City homecomings, civic picnics, and Fourth of July celebrations.

SLOVAK DANCE TROUPE AT SEPTEMBER-FEST, 1981. West Allis has hosted a number of ethnic festivals. In 1981, September-fest at Veteran's Park was a place for demonstrations of European heritage and food. This merry troupe demonstrated Slovak dance. Left to right, Lori Yakloch, Lonie Limoni, and Kathy Beaginc. West Allis is also the new home of Holiday Folk Fair which is an all encompassing ethnic festival held at the exposition building at State Fair Park in November.

THE INCOMPARABLE LIBERACE (1919–1987) AND BROTHER GEORGE, 1957. Wladzui (Walter) Liberace was born in West Allis in 1919. The family ran a small grocery and lived in a modest home on Hawley Road, today's 1649 South Sixtieth Street. All members of the Liberace family were talented musicians. In 1926, the family moved to the Village of West Milwaukee where the children attended school. Liberace graduated from West Milwaukee High School in 1937. From that time forward he gained notoriety playing piano in clubs across the eastern United States, eventually rising to the reputation of America's most talented and flamboyant pianist. Liberace is shown here in a publicity still for a concert at Milwaukee's Schroeder Hotel in August, 1957. (Photo courtesy of the Journal Sentinel Inc.)

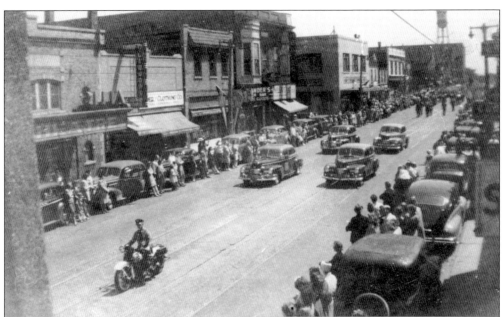

DECORATION DAY PARADE, 1946. West Allis loves parades and Greenfield Avenue is the thoroughfare of choice. It's Decoration Day (forerunner of Flag Day) 1946, and the police department leads the parade west through the downtown business district. To this day, West Allis puts on some of the best parades in Milwaukee County.

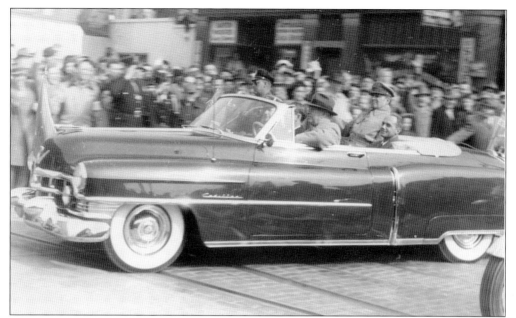

GENERAL DOUGLAS MACARTHUR, 1950. General MacArthur was a long time visitor to the Milwaukee area. When in Milwaukee he would take up residence in the Plankinton Hotel. In this photo his motorcade rolls up Greenfield Avenue as West Allisans turn out to greet the World War II hero.

MISS WEST ALLIS, 1981. The Miss West Allis competition is a platform for the young women of the city to demonstrate their poise, intellect, and talents. Miss West Allis represents the City of West Allis in the Miss Wisconsin Pageant. In April 1981, Deborah Hart wins the title and is crowned by her predecessor, Tracy Stefaniak, Miss West Allis 1980.

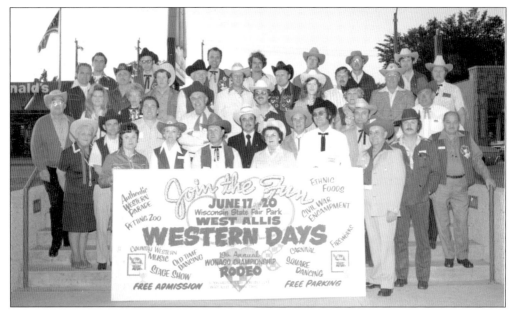

WEST ALLIS WESTERN DAYS VOLUNTEERS, C. 1968. West Allis Western Days is the major fund raising event for West Allis Charities. West Allis Charities provided temporary financial assistance for individuals, groups, and organizations in the city. The volunteers are the heart of any charitable organization and over the years folks like those shown here enthusiastically accept the challenge to prepare the largest horse-powered parade in the country, as well as organize the entertainment for this three-day, Western style festival. (Photo courtesy of West Allis Charities Inc.)

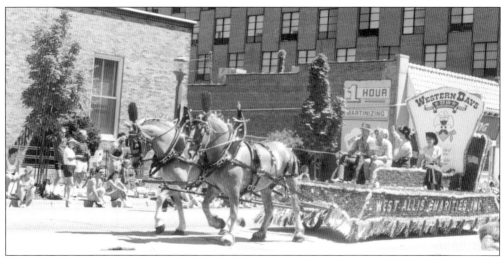

WESTERN DAYS PARADE, 25TH ANNIVERSARY, 1989. West Allis Charities was founded in 1964 by Warren Hirshinger, Urban Ganser, Joe Dragan, Chet Mikolajek, Herb Velser, and Tom Hutchinson. These far-sighted, service-oriented men saw a need for a single organization supported by volunteers and local business that would provide supplemental funding for community projects. From the proceeds of the Western Days events, the Charities, over the years, has provided scholarships, purchased medical equipment for schools, provided funding for the West Allis paramedic program, given funds for the Library atrium, and sponsors the yearly Christmas parade, to name only a few programs and projects.

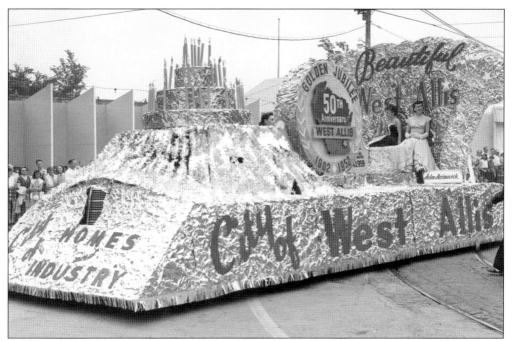

WEST ALLIS 50TH ANNIVERSARY PARADE, CITY OF WEST ALLIS FLOAT, 1952.

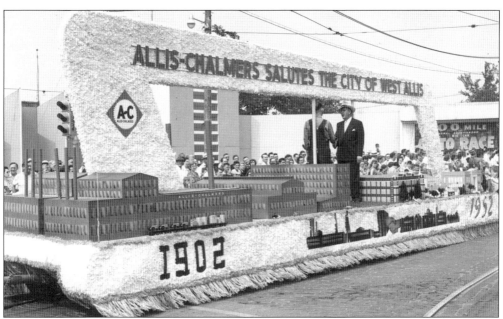

ALLIS CHALMERS COMPANY FLOAT, 1952. In 1952, the City of West Allis celebrated the 50th anniversary of the founding of the Village of West Allis. This landmark year was filled with enthusiasm and civic pride. The parade was made up of marching bands from across the Midwest, color guards from every American Legion, VFW Post, school bands, and floats of all shapes and sizes recalling historic events or paying tribute to the Capital of Wisconsin manufacturing. The parade wound its way through the downtown and pioneer business districts. The finish at State Fair Park boasted food and festivities, culminated in a grand fireworks show.

MAYOR JEANNETTE BELL PORTRAYS A PIONEER DEDICATING THE HONEY CREEK LOG SCHOOL, 1998. The City of West Allis formed a special committee in 1997 to plan a civic project to celebrate the sesquicentennial of the State of Wisconsin. The Sesquicentennial Committee conceived and built a reconstruction of the Honey Creek Log School that stood on the Honey Creek Park site in the 1840s. Not only did the group raise the funds, they also raised the logs and finished the structure with the help of many West Allisans. Afterward, the committee formed the nucleus of the Historic Preservation Commission. The school building is used as an educational site for local schools studying pioneer history.

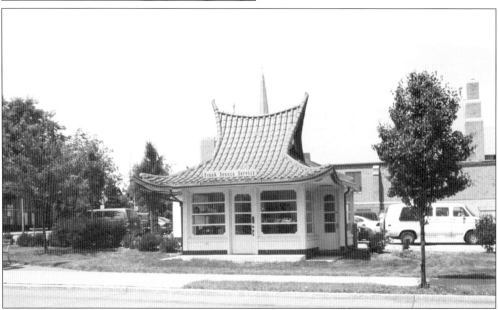

SENECA STATION HISTORIC SITE, 2003. This Wadhams Gas Station at South Seventy-sixth Street at National Avenue was owned and operated by West Allis businessman Frank Seneca from 1938 to 1978. The pagoda station was built in 1927 in the oriental "pagoda" style that many Americans found exotic and fascinating. The city acquired the property in 1999 and restored it. Through the efforts of many citizens and the Historic Commission, the site was opened for public view in May 2000.

WEST ALLIS HISTORICAL SOCIETY BUILDING AS SEEN FROM THE HONEY CREEK CEMETERY, 2003. This building is a wonderful example of Richardson Romanesque architecture. The building was originally the Greenfield Township's Fifth District School and was built of "Cream City" brick in 1887. It was also known as Garfield School and served as a school until 1924. It has been the home of the West Allis Historical Society Museum for nearly 40 years and boasts recreations of old West Allis businesses and a number of exhibits on life in the factories and the city. The Historical Society is an all volunteer organization that performs a wonderful service in caring for the City history.

"THE FAMILY." This burnished stainless steel figural group was created by artist Joe Puccetti and was given to the citizens of West Allis by the artist in 1982. The work stands in the City Hall courtyard as a reminder to everyone who passes that West Allis is a community based in family values.

SUGGESTED READING

Aderman, Ralph M. ed. *Trading Post to Metropolis, Milwaukee County's First 150 Years.* Milwaukee County Historical Society. Milwaukee, WI. 1987.

Burbach, Julius H. *Historical Review of West Allis.* J.H. Burbach/Craftsman Press. Milwaukee, 1927.

Fisher, Esther L. *A Brief History of the City of Greenfield, 1841–1976.* Greenfield Historical Society. Greenfield, WI. 1976.

Jackson, Kenneth T. *Crabgrass Frontier: the suburbanization of the United States.* Oxford University Press. New York, 1985.

Peterson, Walter F. *An Industrial Heritage, Allis Chalmers Corporation.* Milwaukee County Historical Society. Milwaukee, WI. 1978.

Thompson, William F. general editor. *The History of Wisconsin.* 6 volumes. State Historical Society of Wisconsin. Madison, WI. 1973.

Zimmerman, Jerry. *150 Years of the Wisconsin State Fair: an illustrated history, 1851–2001.* Wisconsin State Fair Park. West Allis, WI. 2001.